EASTERN SHADOWS

JAPANESE GHOST, MONSTER & WARRIOR TALES
WITH ART BY KUNIYOSHI, YOSHITOSHI & OTHERS

UKIYO-E MASTER SERIES : VOLUME ELEVEN

EASTERN SHADOWS
ILLUSTRATED JAPANESE GHOST & MONSTER TALES
Created by Jack Hunter
Published 2013 by Shinbaku Books
ISBN 978-1-84068-313-4
All world rights reserved
Printed in China
UKIYO-E MASTER SERIES: VOLUME ELEVEN

真☆爆
SHINBAKU

FOREWORD

In the late 19th and early 20th century, several Western writers who visited the newly-opened Japan assimilated, translated and published a host of weird, scary and stirring stories from the country's ancient folklore. Lafcadio Hearn, Yei Theodora Ozaki and others between them wrote several such volumes, covering mythic figures such as Raiko the monster-hunter, Kintaro the Golden Boy, and the great warrior-hero Yoshitsune.

Eastern Shadows features more than 20 of these classic tales and legends of old Japan, including stories of ghosts, demons, shape-shifting goblins, cannibal ogres, giant serpents, evil magicians, and the mighty warriors who fought and defeated them.

The book is illustrated by over 90 rare and exceptional Japanese woodblock prints of the mythic and supernatural, presented in full-page format and full colour throughout. The artists featured in the book include Yoshitsuya, Yoshikazu, Kuniyoshi, Yoshiharu, Kunichika, Kunisada, Kyosai, Kunimune, Ekin, Yoshitoshi, Eisen, Toyokuni, Hokusai, Kunitsuna,

Shuntei, and Sadahide – a list of many of the most outstanding *ukiyo-e* artists of Edo and Meiji, each of whom used their immense artistic talent and imagination to brilliantly illuminate these classic stories.

ILLUSTRATIONS

Page 1: Kintaro fighting a giant snake; art by Yoshitsuya (c.1850).
Page 2-3: The bandit leader Ise Saburo Yoshimori meets Ushiwakamaru on Yahagi bridge; art by Yoshitsuya (1861).
Page 4: Hero and dragon; art by Yoshitsuya, from the series **Mirror Of Our Country's Warriors** (1856).
Page 5: Driving out a demon; art by Kuniyoshi, from the illustrated book **Lives Of 100 Generals** (1848).
Page 6: Tamatori-hime stealing a sacred jewel from the Dragon King (two triptych panels); art by Kuniyoshi (c.1848).
Page 7: Ushiwakamaru menaced by a demonic warrior; art by Yoshitsuya (c.1858).

THE GOBLIN-SPIDER

In very ancient books it is said that there used to be many goblin-spiders in Japan.

Some folks declare there are still some goblin-spiders. During the daytime they look just like common spiders; but very late at night, when everybody is asleep, and there is no sound, they become very, very big, and do awful things. Goblin-spiders are supposed also to have the magical power of taking human shape, so as to deceive people. And there is a famous Japanese story about such a spider.

There was once, in some lonely part of the country, a haunted temple. No one could live in the building because of the goblins that had taken possession of it. Many brave *samurai* went to that place at various times for the purpose of killing the goblins. But they were never heard of again after they had entered the temple.

At last one who was famous for his courage and his prudence, went to the temple to watch during the night. And he said to those who accompanied him there: "If in the morning I am still alive, I shall drum upon the drum of the temple." Then he was left alone, to watch by the light of a lamp.

As the night advanced he crouched down under the altar, which supported a dusty image of Buddha. He saw nothing strange and heard no sound till after midnight. Then there came a goblin, having but half a body and one eye, and said: "*Hitokusai!*" ["There is the smell of a man".] But the *samurai* did not move. The goblin went away.

Then there came a priest and played upon a *samisen* so wonderfully that the *samurai* felt sure it was not the playing of a man. So he leaped up with his sword drawn. The priest, seeing him, burst out laughing, and said: "So you thought I was a goblin? Oh no! I am only the priest of this temple; but I have to play to keep off the goblins. Does not this *samisen* sound well? Please play a little."

And he offered the instrument to the *samurai* who grasped it very cautiously with his left hand. But instantly the *samisen* changed into a monstrous spider web, and the priest into a goblin and the warrior found himself caught fast in the web by the left hand. He struggled bravely, and struck at the spider with his sword, and wounded it; but he soon became entangled still more in the net, and could not move.

However, the wounded spider crawled away, and the sun rose, in a little while the people came and found the *samurai* in the horrible web, and freed him. They saw tracks of blood upon the floor, and followed the tracks out of the temple to a hole in the deserted garden. Out of the hole issued a frightful sound of groaning. They found the wounded goblin in the hole, and killed it.

ILLUSTRATIONS
Page 8: Kamigashi-hime killing a goblin-spider; art by Kuniyoshi (c.1825).
Page 9: *Samurai* trapped by a goblin-spider; art by Keisai Eisen, from the book **A Pictorial History Of Heroes** (*Eiyu gashi*, 1836).
Page 10: Kamu-natsu-so-hime killing a goblin-spider; art by Katsukawa Shuntei (c.1810).
Page 11: Soma Yoshikado menaced by a goblin-spider (detail); art by Kuniyoshi, from the series **Ukiyo-e Comparisons For The Chapters of Genji** (*Genji kumo ukiyoe awase*, 1845-46).

IBARAKI, DEMON OF RASHOMON

Long, long ago in Kyoto, the people of the city were terrified by accounts of a dreadful ogre, who, it was said, haunted the Gate of Rashomon at twilight and seized whoever passed by. The missing victims were never seen again, so it was whispered that the ogre was a horrible cannibal, who not only killed the unhappy victims but ate them also. Now everybody in the town and neighborhood was in great fear, and no one dared venture out after sunset near the Gate of Rashomon.

Now at this time there lived in Kyoto a general named Raiko, who had made himself famous for his brave deeds. Some time before this he made the country ring with his name, for he had attacked Oeyama, where a band of ogres lived with their chief, who instead of wine drank the blood of human beings. He had routed them all and cut off the head of the chief monster.

This brave warrior was always followed by a band of faithful knights. In this band there were five knights of great valor. One evening as the five knights sat at a feast quaffing *sake* in their rice bowls and eating all kinds of fish, raw, and stewed, and broiled, and toasting each other's healths and exploits, the first knight, Hojo, said to the others:

"Have you all heard the rumor that every evening after sunset there comes an ogre to the Gate of Rashomon, and that he seizes all who pass by?"

The second knight, Watanabe, answered him, saying:

"Do not talk such nonsense! All the ogres were killed by our chief Raiko at Oeyama! It cannot be true, because even if any ogres did escape from that great killing they would not dare to show themselves in this city, for they know that our brave master would at once attack them if he knew that any of them were still alive!"

"Then do you disbelieve what I say, and think that I am telling you a falsehood?"

"No, I do not think that you are telling a lie," said Watanabe; "but you have heard some old woman's story

which is not worth believing."

"Then the best plan is to prove what I say, by going there yourself and finding out yourself whether it is true or not," said Hojo.

Watanabe, the second knight, could not bear the thought that his companion should believe he was afraid, so he answered quickly:

"Of course, I will go at once and find out for myself!"

So Watanabe at once got ready to go – he buckled on his long sword and put on a coat of armor, and tied on his large helmet. When he was ready to start he said to the others:

"Give me something so that I can prove I have been there!"

Then one of the men got a roll of writing paper and his box of Indian ink and brushes, and the four comrades wrote their names on a piece of paper.

"I will take this," said Watanabe, "and put it on the Gate of Rashomon, so to-morrow morning will you all go and look at it? I may be able to catch an ogre or two by then!" and he mounted his horse and rode off gallantly. It was a very dark night, and there was neither moon nor star to light Watanabe on his way. To make the darkness worse a storm came on, the rain fell heavily and the wind howled like wolves in the mountains. Any ordinary man would have trembled at the thought of going out of doors, but Watanabe was a brave warrior and dauntless, and his honor and word were at stake, so he sped on into the night, while his companions listened to the sound of his horse's hoofs dying away in the distance, then shut the sliding shutters close and gathered round the charcoal fire and wondered what would happen – and whether their comrade would encounter one of those horrible Oni.

At last Watanabe reached the Gate of Rashomon, but peer as he might through the darkness he could see no sign of an ogre.

"It is just as I thought," said Watanabe to himself; "there are certainly no ogres here; it is only an old woman's story. I will stick this paper on the gate so that the others can see I have been here when they come to-morrow, and then I will take my way home and laugh at them all."

He fastened the piece of paper, signed by all his four companions, on the gate, and then turned his horse's head towards home.

As he did so he became aware that some one was behind him, and at the same time a voice called out to him to wait. Then his helmet was seized from the back. "Who are you?" said Watanabe fearlessly. He then put out his hand and groped around to find out who or what it was that held him by the helmet. As he did so he touched something that felt like an arm – it was covered with hair and as big round as the trunk of a tree!

Watanabe knew at once that this was the arm of an ogre, so he drew his sword and cut at it fiercely.

There was a loud yell of pain, and then the ogre dashed in front of the warrior.

Watanabe's eyes grew large with wonder, for he saw that the ogre was taller than the great gate, his eyes were flashing like mirrors in the sunlight, and his huge mouth was wide open, and as the monster breathed, flames of fire shot out of his mouth.

The ogre thought to terrify his foe, but Watanabe never flinched. He attacked the ogre with all his strength, and thus they fought face to face for a long time. At last the ogre, finding that he could neither frighten nor beat Watanabe and that he might himself be beaten, took to flight. But Watanabe, determined not to let the monster escape, put spurs to his horse and gave chase.

But though the knight rode very fast the ogre ran faster, and to his disappointment he found himself unable to overtake the monster, who was gradually lost to sight.

Watanabe returned to the gate where the fierce fight had taken place, and got down from his horse. As he did so he stumbled upon something lying on the ground.

Stooping to pick it up he found that it was one of the ogre's huge arms which he must have slashed off in the fight. His joy was great at having secured such a prize, for this was the best of all proofs of his adventure with the ogre. So he took it up carefully and carried it home as a trophy of his victory.

When he got back, he showed the arm to his comrades, who one and all called him the hero of their band and gave him a great feast. His wonderful deed was soon noised abroad in Kyoto, and people from far and near came to see the ogre's arm.

Watanabe now began to grow uneasy as to how he should keep the arm in safety, for he knew that the ogre to whom it belonged was still alive. He felt sure that one day or other, as soon as the ogre got over his scare, he would come to try to get his arm back again. Watanabe therefore had a box made of the strongest wood and banded with iron. In this he placed the arm, and then he sealed down the heavy lid, refusing to open it for anyone. He kept the box in his own room and took charge of it himself, never allowing it out of his sight.

Now one night he heard some one knocking at the porch, asking for admittance.

When the servant went to the door to see who it was, there was only an old woman, very respectable in appearance. On being asked who she was and what was her business, the old woman replied with a smile that she

had been nurse to the master of the house when he was a little baby. If the lord of the house were at home she begged to be allowed to see him.

The servant left the old woman at the door and went to tell his master that his old nurse had come to see him. Watanabe thought it strange that she should come at that time of night, but at the thought of his old nurse, who had been like a foster-mother to him and whom he had not seen for a long time, a very tender feeling sprang up for her in his heart. He ordered the servant to show her in.

The old woman was ushered into the room, and after the customary bows and greetings were over, she said:

"Master, the report of your brave fight with the ogre at the Gate of Rashomon is so widely known that even your poor old nurse has heard of it. Is it really true, what every one says, that you cut off one of the ogre's arms? If you did, your deed is highly to be praised!"

"I was very disappointed," said Watanabe, "that I was not able take the monster captive, which was what I wished to do, instead of only cutting off an arm!"

"I am very proud to think," answered the old woman, "that my master was so brave as to dare to cut off an ogre's arm. There is nothing that can be compared to your courage. Before I die it is the great wish of my life to see this arm," she added pleadingly.

"No," said Watanabe, "I am sorry, but I cannot grant your request."

"But why?" asked the old woman.

"Because," replied Watanabe, "ogres are very revengeful creatures, and if I open the box there is no telling

but that the ogre may suddenly appear and carry off his arm. I have had a box made on purpose with a very strong lid, and in this box I keep the ogre's arm secure; and I never show it to any one, whatever happens."

"Your precaution is very reasonable," said the old woman. "But I am your old nurse, so surely you will not refuse to show *me* the arm. I have only just heard of your brave act, and not being able to wait till the morning I came at once to ask you to show it to me."

Watanabe was very troubled at the old woman's pleading, but he still persisted in refusing. Then the old woman said:

"Do you suspect me of being a spy sent by the ogre?"

"No, of course I do not suspect you of being the ogre's spy, for you are my old nurse," answered Watanabe.

"Then you cannot surely refuse to show me the arm any longer." entreated the old woman; "for it is the great wish of my heart to see for once in my life the arm of an ogre!"

Watanabe could not hold out in his refusal any longer, so he gave in at last, saying:

"Then I will show you the ogre's arm, since you so earnestly wish to see it. Come, follow me!" and he led the way to his own room, the old woman following.

When they were both in the room Watanabe shut the door carefully, and then going towards a big box which stood in a corner of the room, he took off the heavy lid. He then called to the old woman to come near and look in, for he never took the arm out of the box.

"What is it like? Let me have a good look at it," said the old nurse, with a joyful face.

She came nearer and nearer, as if she were afraid, till she stood right against the box. Suddenly she plunged her hand into the box and seized the arm, crying with a fearful voice which made the room shake:

"Oh, joy! I have got my arm back again!"

And from an old woman she was suddenly transformed into the towering figure of the frightful ogre!

Watanabe sprang back and was unable to move for a moment, so great was his astonishment; but recognizing the ogre who had attacked him at the Gate of Rashomon, he determined with his usual courage to put an end to him this time. He seized his sword, drew it out of its sheath in a flash, and tried to cut the ogre down.

So quick was Watanabe that the creature had a narrow escape. But the ogre sprang up to the ceiling, and bursting through the roof, disappeared in the mist and clouds.

In this way the ogre escaped with his arm. The knight gnashed his teeth with disappointment, but that was all he could do. He waited in patience for another opportunity to dispatch the ogre. But the latter was afraid of Watanabe's great strength and daring, and never troubled Kyoto again. So once more the people of the city were able to go out without fear even at night time, and the brave deeds of Watanabe have never been forgotten!

ILLUSTRATIONS
Page 12: Watanabe no Tsuna about to cut off Ibaraki's arm; art by Kuniyoshi (1825).
Page 13: Ichikawa Sadanji I in the role of Watanabe no Tsuna and Onoe Kikugoro V in the role of Ibaraki; art by Kunichika, from the *kabuki* dance drama **Ibaraki** (1890).
Page 15: The demon Ibaraki (detail from vertical diptych); art by Yoshitoshi (1888).
Page 16: Watanabe no Tsuna and Ibaraki; art by Kunisada (c.1815).
Page 17: Watanabe no Tsuna and Ibaraki; art (painted panel) by Ekin (c.1850).
Page 18: Watanabe no Tsuna and Ibaraki; art by Kunimune (c.1820).

侍女於古寺

THE DEVIL CAT OF NEBESHIMA

There is a tradition in the Nabéshima family (of the Hizen daimyo) that, many years ago, the Prince of Hizen was bewitched and cursed by a cat that had been kept by one of his retainers. This prince had in his house a lady of rare beauty, called O Toyo: amongst all his ladies she was the favourite, and there was none who could rival her charms and accomplishments. One day the Prince went out into the garden with O Toyo, and remained enjoying the fragrance of the flowers until sunset, when they returned to the palace, never noticing that they were being followed by a large cat. Having parted with her lord, O Toyo retired to her own room and went to bed. At midnight she awoke with a start, and became aware of a huge cat that crouched watching her; and when she cried out, the beast sprang on her, and, fixing its cruel teeth in her delicate throat, throttled her to death. What a piteous end for so fair a dame, the darling of her prince's heart, to die suddenly, bitten to death by a cat! Then the cat, having scratched out a grave under the verandah, buried the corpse of O Toyo, and assuming her form, began to bewitch the Prince.

But my lord the Prince knew nothing of all this, and little thought that the beautiful creature who caressed and fondled him was an impish and foul beast that had slain his mistress and assumed her shape in order to drain out his life's blood. Day by day, as time went on, the Prince's strength dwindled away; the colour of his face was changed, and became pale and livid; and he was as a man suffering from a deadly sickness. Seeing this, his councillors and his wife became greatly alarmed; so they summoned the physicians, who prescribed various remedies for him; but the more medicine he took, the more serious did his illness appear, and no treatment was of any avail. But most of all did he suffer in the night-time, when his sleep would be troubled and disturbed by hideous dreams. In consequence of this, his councillors nightly appointed a hundred of his retainers to sit up and watch over him; but, strange to say, towards ten o'clock on the very first night that the watch was set, the guard were seized with a sudden and unaccountable drowsiness, which they could not resist, until one by one every man had fallen asleep. Then the false O Toyo came in and harassed the Prince until morning. The following night the same thing occurred, and the Prince

was subjected to the imp's tyranny, while his guards slept helplessly around him. Night after night this was repeated, until at last three of the Prince's councillors determined themselves to sit up on guard, and see whether they could overcome this mysterious drowsiness; but they fared no better than the others, and by ten o'clock were fast asleep. The next day the three councillors held a solemn conclave, and their chief, one Isahaya Buzen, said—

"This is a marvellous thing, that a guard of a hundred men should thus be overcome by sleep. Of a surety, the spell that is upon my lord and upon his guard must be the work of witchcraft. Now, as all our efforts are of no avail, let us seek out Ruiten, the chief priest of the temple called Miyô In, and beseech him to put up prayers for the recovery of my lord."

And the other councillors approving what Isahaya Buzen had said, they went to the priest Ruiten and engaged him to recite litanies that the Prince might be restored to health.

So it came to pass that Ruiten, the chief priest of Miyô In, offered up prayers nightly for the Prince. One night, at the ninth hour (midnight), when he had finished his religious exercises and was preparing to lie down to sleep, he fancied that he heard a noise outside in the garden, as if some one were washing himself at the well. Deeming this passing strange, he looked down from the window; and there in the moonlight he saw a handsome young soldier, some twenty-four years of age, washing himself, who, when he had finished cleaning himself and had put on his clothes, stood before the figure of Buddha and prayed fervently for the recovery of my lord the Prince. Ruiten looked on with admiration; and the young man, when he had made an end of his prayer, was going away; but the priest stopped him, calling out to him—

"Sir, I pray you to tarry a little: I have something to say to you."

"At your reverence's service. What may you please to want?"

"Pray be so good as to step up here, and have a little talk."

"By your reverence's leave;" and with this he went upstairs.

Then Ruiten said—

"Sir, I cannot conceal my admiration that you, being so young a man, should have so loyal a spirit. I am Ruiten, the chief priest of this temple, who am engaged in praying for the recovery of my lord. Pray what is your name?"

"My name, sir, is Itô Sôda, and I am serving in the infantry of Nabéshima. Since my lord has been sick, my one desire has been to assist in nursing him; but, being only a simple soldier, I am not of sufficient rank to come into his presence, so I have no resource but to pray to the gods of the country and to Buddha that my lord may regain his health."

When Ruiten heard this, he shed tears in admiration of the fidelity of Itô Sôda, and said—

"Your purpose is, indeed, a good one; but what a strange sickness this is that my lord is afflicted with! Every night he suffers from horrible dreams; and the retainers who sit up with him are all seized with a mysterious sleep, so that not one can keep awake. It is very wonderful."

"Yes," replied Sôda, after a moment's reflection, "this certainly must be witchcraft. If I could but obtain leave to sit up one night with the Prince, I would fain see whether I could not resist this drowsiness and detect the goblin."

At last the priest said, "I am in relations of friendship with Isahaya Buzen, the chief councillor of the Prince. I will speak to him of you and of your loyalty, and will intercede with him that you may attain your wish."

"Indeed, sir, I am most thankful. I am not prompted by any vain thought of self-advancement, should I succeed: all I wish for is the recovery of my lord. I commend myself to your kind favour."

"Well, then, to-morrow night I will take you with me to the councillor's house."

"Thank you, sir, and farewell." And so they parted.

On the following evening Itô Sôda returned to the temple Miyô In, and having found Ruiten, accompanied him to the house of Isahaya Buzen: then the priest, leaving Sôda outside, went in to converse with the councillor, and inquire after the Prince's health.

"And pray, sir, how is my lord? Is he in any better condition since I have been offering up prayers for him?"

"Indeed, no; his illness is very severe. We are certain that he must be the victim of some foul sorcery; but as there are no means of keeping a guard awake after ten o'clock, we cannot catch a sight of the goblin, so we are in the greatest trouble."

"I feel deeply for you: it must be most distressing. However, I have something to tell you. I think that I have found a man who will detect the goblin; and I have brought him with me."

"Indeed! who is the man?"

"Well, he is one of my lord's foot-soldiers, named Itô Sôda, a faithful fellow, and I trust that you will grant his request to be permitted to sit up with my lord."

"Certainly, it is wonderful to find so much loyalty and zeal in a common soldier," replied Isahaya Buzen, after a moment's reflection; "still it is impossible to allow a man of such low rank to perform the office of watching over my lord."

"It is true that he is but a common soldier," urged the priest; "but why not raise his rank in consideration of his fidelity, and then let him mount guard?"

"It would be time enough to promote him after my lord's recovery. But come, let me see this Itô Sôda, that I may know what manner of man he is: if he pleases me, I will consult with the other councillors, and perhaps we may grant his request." "I will bring him in forthwith," replied Ruiten, who thereupon went out to fetch the young man.

When he returned, the priest presented Itô Sôda to the councillor, who looked at him attentively, and, being pleased with his comely and gentle appearance, said—

"So I hear that you are anxious to be permitted to mount guard in my lord's room at night. Well, I must consult with the other councillors, and we will see what can be done for you."

When the young soldier heard this he was greatly elated, and took his leave, after warmly thanking Buiten, who had helped him to gain his object. The next day the councillors held a meeting, and sent for Itô Sôda, and told him that he might keep watch with the other retainers that very night. So he went his way in high spirits, and at nightfall, having made all his preparations, took his place among the hundred gentlemen who were on duty in the prince's bed-room.

Now the Prince slept in the centre of the room, and the hundred guards around him sat keeping themselves awake with entertaining conversation and pleasant conceits. But, as ten o'clock approached, they began to doze off as they sat; and in spite of all their endeavours to keep one another awake, by degrees they all fell asleep. Itô Sôda all this while felt an irresistible desire to sleep creeping over him, and, though he tried by all sorts of ways to rouse himself, he saw that there was no help for it, but by resorting to an extreme measure, for which he had already made his preparations. Drawing out a piece of oil paper which he had brought with him, and spreading it over the mats, he sat down upon it; then he took the small knife which he carried in the sheath of his dirk, and stuck it into his own thigh. For awhile the pain of the wound kept him awake; but as the slumber by which he was assailed was the work of sorcery, little by little he became drowsy again. Then he twisted the knife round and round in his thigh, so that the pain becoming very violent, he was proof against the feeling of sleepiness, and kept a faithful watch. Now the oil paper which he had spread under his legs was in order to prevent the blood, which might spurt from his wound, from

defiling the mats.

So Itô Sôda remained awake, but the rest of the guard slept; and as he watched, suddenly the sliding-doors of the Prince's room were drawn open, and he saw a figure coming in stealthily, and, as it drew nearer, the form was that of a marvellously beautiful woman some twenty-three years of age. Cautiously she looked around her; and when she saw that all the guard were asleep, she smiled an ominous smile, and was going up to the Prince's bedside, when she perceived that in one corner of the room there was a man yet awake. This seemed to startle her, but she went up to Sôda and said—

"I am not used to seeing you here. Who are you?"

"My name is Itô Sôda, and this is the first night that I have been on guard."

"A troublesome office, truly! Why, here are all the rest of the guard asleep. How is it that you alone are awake? You are a trusty watchman."

"There is nothing to boast about. I'm asleep myself, fast and sound."

"What is that wound on your knee? It is all red with blood."

"Oh! I felt very sleepy; so I stuck my knife into my thigh, and the pain of it has kept me awake."

"What wondrous loyalty!" said the lady.

"Is it not the duty of a retainer to lay down his life for his master? Is such a scratch as this worth thinking about?"

Then the lady went up to the sleeping prince and said, "How fares it with my lord to-night?" But the Prince, worn out with sickness, made no reply. But Sôda was watching her eagerly, and guessed that it was O Toyo, and made up his mind that if she attempted to harass the Prince he would kill her on the spot. The goblin, however, which in the form of O Toyo had been tormenting the Prince every night, and had come again that night for no other purpose, was defeated by the watchfulness of Itô Sôda; for whenever she drew near to the sick man, thinking to put her spells upon him, she would turn and look behind her, and there she saw Itô Sôda glaring at her; so she had no help for it but to go away again, and leave the Prince undisturbed.

At last the day broke, and the other officers, when they awoke and opened their eyes, saw that Itô Sôda had kept awake by stabbing himself in the thigh; and they were greatly ashamed, and went home crestfallen.

That morning Itô Sôda went to the house of Isahaya Buzen, and told him all that had occurred the previous night. The councillors were all loud in their praises of Itô Sôda's behaviour, and ordered him to keep watch again that night. At the same hour, the false O Toyo came and looked all round the room, and all the guard were asleep, excepting Itô Sôda, who was wide awake; and so, being again frustrated, she returned to her own apartments.

Now as since Sôda had been on guard the Prince had passed quiet nights, his sickness began to get better, and there was great joy in the palace, and Sôda was promoted and rewarded with an estate. In the meanwhile O Toyo, seeing that her nightly visits bore no fruits, kept away; and from that time forth the night-guard were no longer subject to fits of drowsiness. This coincidence struck Sôda as very strange, so he went to Isahaya Buzen and told him that of a certainty this O Toyo was no other than a goblin. Isahaya Buzen reflected for a while, and said—

"Well, then, how shall we kill the foul thing?"

"I will go to the creature's room, as if nothing were the matter, and try to kill her; but in case she should try to escape, I will beg you to order eight men to stop outside and lie in wait for her."

Having agreed upon this plan, Sôda went at nightfall to O Toyo's apartment, pretending to have been sent with a message from the Prince. When she saw him arrive, she said—

"What message have you brought me from my lord?"

"Oh! nothing in particular. Be so look as to look at this letter;" and as he spoke, he drew near to her, and suddenly drawing his dirk cut at her; but the goblin, springing back, seized a halberd, and glaring fiercely at Sôda, said—

"How dare you behave like this to one of your lord's ladies? I will have you dismissed;" and she tried to strike Sôda with the halberd. But Sôda fought desperately with his dirk; and the goblin, seeing that she was no match for him, threw away the halberd, and from a beautiful woman became suddenly transformed into a cat, which, springing up the sides of the room, jumped on to the roof. Isahaya Buzen and his eight men who were watching outside shot at the cat, but missed it, and the beast made good its escape.

So the cat fled to the mountains, and did much mischief among the surrounding people, until at last the Prince of Hizen ordered a great hunt, and the beast was killed.

But the Prince recovered from his sickness; and Itô Sôda was richly rewarded.

ILLUSTRATIONS
Page 20: Cat witch of Okabe (detail from triptych); art by Kunisada, from the *kabuki* play **Hana no saga nekomata hanashi** (1853).
Page 21: Devil cat of Okazaki; art by Kunisada (1847).
Page 25: Monster cat; art by Kunisada (c.1845).

THE GHOST OF OKIKU

About two hundred years ago there was a chief of the police, named Aoyama Shuzen, who lived in the street called Bancho, at Yedo. His duty was to detect thieves and incendiaries. He was a cruel and violent man, without heart or compassion, and thought nothing of killing or torturing a man to gratify spite or revenge. This man Shuzen had in his house a servant-maid, called Okiku ("The Chrysanthemum"), who had lived in the family since her childhood, and was well acquainted with her master's temper.

One day Okiku accidentally broke one of a set of ten porcelain plates, upon which Shuzen set a high value. She knew that she would suffer for her carelessness; but she thought that if she concealed the matter her punishment would be still more severe; so she went at once to her master's wife, and, in fear and trembling, confessed what she had done. When Shuzen came home, and heard that one of his favourite plates was broken, he flew into a violent rage, and took the girl to a cupboard, where he left her bound with cords, and every day cut off one of her fingers. Okiku, tightly bound and in agony, could not move; but at last she contrived to bite or cut the ropes asunder, and, escaping into the garden, threw herself into a well, and was drowned.

From that time forth, every night a voice was heard coming from the well, counting one, two, three, and so on up to nine – the number of the plates that remained unbroken – and then, when the tenth plate should have been counted, would come a burst of lamentation. The servants of the house, terrified at this, all left their master's service, until Shuzen, not having a single retainer left, was unable to perform his public duties; and when the officers of the government heard of this, he was dismissed from his office.

At this time there was a famous priest, called Mikadzuki Shonin, of the temple Denzuin, who, having been told of the affair, came one night to the house, and, when the ghost began to count the plates, reproved the spirit, and by his prayers and admonitions caused it to cease from troubling the living.

ILLUSTRATIONS
Page 26: The ghost of Okiku (detail from vertical triptych); art by Kunichika (1892).
Page 27: The ghost of Okiku rising; art by Kuniyoshi, from the *kabuki* play **Minoriyoshi Kogane no Kikuzuki** (1850).

THE LEGEND OF YUREI-DAKI

Near the village of Kurosaka, in the province of Hoki, there is a waterfall called Yurei-Daki, or *The Cascade of Ghosts*. Near the foot of the fall there is a small Shinto shrine of the god of the locality, whom the people name Taki-Daimyojin; and in front of the shrine is a little wooden money-box – *saisen-bako* – to receive the offerings of believers. And there is a story about that money-box. One icy winter's evening, thirty-five years ago, the women and girls employed at a certain *asa-toriba*, or hemp-factory, in Kurosaka, gathered around the big brazier in the spinning-room after their day's work had been done. Then they amused themselves by telling ghost-stories. By the time that a dozen stories had been told, most of the gathering felt uncomfortable; and a girl cried out, just to heighten the pleasure of fear, "Imagine going this night, all by one's self, to the Yurei-Daki!"

"I'll give all the hemp I spun today," mockingly said one of the party, "to the person who goes!"

"So will I," exclaimed another. "And I," said a third. "All of us," affirmed a fourth... Then from among the spinners stood up one Yasumoto O-Katsu, the wife of a carpenter; she had her only son, a boy of two years old, snugly wrapped up and asleep upon her back. "Listen," said O-Katsu; "if you will all really agree to make over to me all the hemp spun today, I will go to the Yurei-Daki."

Her proposal was received with cries of astonishment, but was finally taken seriously. Each of the spinners in turn agreed to give up her share of the day's work to O-Katsu, if she dared go to the Yurei-Daki. "But how are we to know if she really goes there?" a sharp voice asked. "Why, let her bring back the money-box of the god," answered an old woman whom the spinners called Obaa-San, the Grandmother; "that will be proof enough."

"I'll bring it," cried O-Katsu. And out she darted into the street, with her sleeping boy upon her back.

The night was frosty, but clear. Down the empty street O-Katsu hurried; out of the village, and along the high road she ran – *pichà-pichà* – with the great silence of frozen rice-fields on either hand, and only the stars to light her. Half an hour she followed the open road; then she turned down a narrower way, winding under cliffs, and she soon heard the dull roar of the water. A few minutes more, and the way widened into a glen, and the dull roar suddenly became a loud clamour, and before her she saw, looming against a mass of blackness, the long glimmering of the fall. Dimly she perceived the shrine, the money-box. She rushed forward, put out her hand.

"*Oi! O-Katsu-San!*" suddenly called a warning voice above the crash of the water.

O-Katsu stood motionless, stupefied by terror. "*Oi! O-Katsu-San!*" again pealed the menacing voice, but O-Katsu was really a bold woman. At once recovering from her stupefaction, she snatched up the money-box and ran. She ran on steadily – *pichà-pichà* – till she got to Kurosaka, and thumped at the door of the *asa-toriba*.

How the women and the girls cried out as she entered, panting, with the money-box of the god in her hand! Breathlessly they heard her story; sympathetically they screeched when she told them of the Voice that had called her name, twice, out of the haunted water... What a woman! Brave O-Katsu ! – well had she earned the hemp!

"But your boy must be cold, O-Katsu!" cried the Obaa-San, "let us have him here by the fire!"

"Poor O-Katsu!" said the Obaa-San, helping to remove the wraps in which the boy had been carried, "why, you are all wet behind! Then, with a husky scream, the helper vociferated, "*Ara! It is blood!*"

And out of the wrappings there fell to the floor a blood-soaked bundle of baby clothes that left exposed two small brown feet, and two small brown hands – and nothing more. *The child's head had been torn right off!*

ILLUSTRATION
Page 28: Child-eating demon; art by Yoshiiku, after Hokusai (1890).

真勇競

きよ姫

30

KIYO-HIME

Quiet and shady was the spot in the midst of one of the loveliest valley landscapes in the empire, near the banks of the Hidaka river, where stood the tea-house kept by one Kojima. It was surrounded on all sides by glorious mountains, ever robed with deep forests, silver-threaded with flashing water-falls, to which the lovers of nature paid many a visit, and in which poets were inspired to write stanzas in praise of the white foam and the twinkling streamlets. Here the bonzes loved to muse and meditate, and anon merry picnic parties spread their mats, looped their canvas screens, and feasted out of nests of lacquered boxes, drinking the amber saké from cups no larger nor thicker than an egg-shell, while the sound of guitar and drum kept time to dance and song.

The garden of the tea-house was as lovely a piece of art as the florist's cunning could produce. Those who emerged from the deep woods of the lofty hill called the Dragon's Claw, could see in the tea-house garden a living copy of the landscape before them. There were mimic mountains, (ten feet high), and miniature hills veined by a tiny, path with dwarfed pine groves, and tiny bamboo clumps, and a patch of grass for meadow, and a valley just like the great gully of the mountains, only a thousand times smaller, and but twenty feet long. So perfect was the imitation that even the miniature irrigated rice-fields, each no larger than a checker-board, were in full sprout. To make this little gem of nature in art complete, there fell from over a rock at one end a lovely little waterfall two feet high, which after an angry splash over the stones, rolled on over an absurdly small beech, all white-sanded and pebbled, threading its silver way beyond, until lost in fringes of lilies and aquatic plants. In one broad space imitating a lake, was a lotus pond, lined with iris, in which the fins of gold fish and silver carp flashed in the sunbeams. Here and there the nose of a tortoise protruded, while on a rugged rock sat an old grandfather surveying the scene with one or two of his grand-children asleep on his shell and sunning themselves.

The fame of the tea-house, its excellent fare, and special delicacy of its mountain trout, sugar-jelly and well-flavored rice-cakes, drew hundreds of visitors, especially poetry-parties, and lovers of grand scenery.

Just across the river, which was visible from the verandah of the tea-house, stood the lofty firs that surrounded the temple of the Tendai Buddhists. Hard by was the pagoda, which painted red peeped between the trees. A long row of paper-windowed and tile-roofed dwellings to the right made up the monastery, in which a snowy eye-browed but rosy-faced old abbot and some twenty bonzes dwelt, all shaven-faced and shaven-pated, in crape robes and straw sandals, their only food being water and vegetables.

Not the least noticeable of the array of stone lanterns, and bronze images with aureoles round their heads, and incense burners and holy water tanks, and dragon spouts, was the belfry, which stood on a stone platform. Under its roof hung the massive bronze bell ten feet high, which, when struck with a suspended log like a trip-hammer, boomed solemnly over the valley and flooded three leagues of space with the melody which died away as sweetly as an infant falling in slumber. This mighty bell was six inches thick and weighed several tons.

In describing the tea-house across the river, the story of its sweetest charm, and of its garden the fairest flower must not be left untold. Kiyo, the host's daughter, was a lovely maiden of but eighteen, as graceful as the bamboo reed swaying in the breeze of a moonlit summer's eve, and as pretty as the blossoms of the cherry-tree. Far and wide floated the fame of Kiyo, like the fragrance of the white lilies of Ibuki, when the wind sweeping down the mountain heights, comes perfume-laden to the traveler.

As she busied herself about the garden, or as her white socks slipped over the mat-laid floor, she was the picture of grace itself. When at twilight, with her own hands, she lighted the gay lanterns that hung in festoons along the eaves of the tea-house above the verandah, her bright eyes sparkling, her red petticoats half visible through her semi-transparent crape robe, she made many a young man's heart glow with a strange new feeling, or burn with pangs of jealousy.

Among the priests that often passed by the tea-house on their way to the monastery, were some who were young and handsome.

It was the rule of the monastery that none of the bonzes should drink saké, eat fish or meat, or even stop at the tea-houses to talk with women. But one young bonze named Anchin had rigidly kept the rules. Fish had never passed his mouth; and as for saké, he did not know even its taste. He was very studious and diligent. Every day he learned ten new Chinese characters. He had already read several of the sacred sutras, had made a good beginning in Sanskrit, knew the name of every idol in the temple of the 3,333 images in Kioto, had twice visited the sacred shrine of the Capital, and had uttered the prayer "Namu miō ho ren gé kiō," ("Glory be to the sacred lotus of the law"), counting it on his rosary, five hundred thousand times. For sanctity and learning he had no peer among the young neophytes of the bonzerie.

Alas for Anchin! One day, after returning from a visit to a famous shrine in the Kuanto, (Eastern Japan), as he was passing the tea-house, he caught sight of Kiyo-hime, (the "lady" or "princess" Kiyo), and from that moment his pain of heart began. He returned to his bed of mats, but not to sleep. For days he tried to stifle his passion, but his heart only smouldered away like an incense-stick.

Before many days he made a pretext for again passing the house. Hopelessly in love, without waiting many days he stopped and entered the tea-house.

His call for refreshments was answered by Kiyo-hime herself!

As fire kindles fire, so priest and maiden were now consumed in one flame of love. To shorten a long story, Anchin visited the inn oftener and oftener, even stealing out at night to cross the river and spend the silent hours with his love.

So passed several months, when suddenly a change come over the young bonze. His conscience began to

trouble him for breaking his vows. In the terrible conflict between principle and passion, the soul of the priest was tossed to and fro like the feathered seed-ball of a shuttlecock.

But conscience was the stronger, and won.

He resolved to drown his love and break off his connection with the girl. To do it suddenly, would bring grief to her and a scandal both on her family and the monastery. He must do it gradually to succeed at all.

Ah! how quickly does the sensitive love-plant know the finger-tip touch of cooling passion! How quickly falls the silver column in the crystal tube, at the first breath of the heart's chill even though the words on the lip are warm! Kiyo-hime marked the ebbing tide of her lover's regard, and then a terrible resolve of evil took possession of her soul. From that time forth, she ceased to be a pure and innocent and gentle virgin. Though still in maiden form and guise, she was at heart a fox, and as to her nature she might as well have worn the bushy tail of the sly deceiver. She resolved to win over her lover, by her importunities, and failing in this, to destroy him by sorcery.

One night she sat up until two o'clock in the morning, and then, arrayed only in a white robe, she went out to a secluded part of the mountain where in a lonely shrine stood a hideous scowling image of Fudo, who holds the sword of vengeance and sits clothed in fire. There she called upon the god to change her lover's heart or else destroy him.

Thence, with her head shaking, and eyes glittering with anger like the orbs of a serpent, she hastened to the shrine of Kampira, whose servants are the long-nosed sprites, who have the power of magic and of teaching sorcery. Standing in front of the portal she saw it hung with votive tablets, locks of hair, teeth, various tokens of vows, pledges and marks of sacrifice, which the devotees of the god had hung up. There, in the cold night air she asked for the power of sorcery, that she might be able at will to transform herself into the terrible *ja* – the awful dragon-serpent whose engine coils are able to crack bones, crush rocks, melt iron or root up trees, and which are long enough to wind round a mountain.

It would be too long to tell how this once pure and happy maiden, now turned to an avenging demon went out nightly on the lonely mountains to practice the arts of sorcery. The mountain-sprites were her teachers, and she learned so diligently that the chief goblin at last told her she would be able, without fail, to transform herself when she wished.

The dreadful moment was soon to come. The visits of the once lover-priest gradually became fewer and fewer, and were no longer tender hours of love, but were on his part formal interviews, while Kiyo-hime became more importunate than ever. Tears and pleadings were alike useless, and finally one night as he was taking leave, the bonze told the maid that he had paid his last visit. Kiyo-hime then utterly forgetting all womanly delicacy, became so urgent that the bonze tore himself away and fled across the Hidaka river. He had seen the terrible gleam in the maiden's eyes, and now terribly frightened, hid himself under the great temple bell.

Forthwith Kiyo-hime, seeing the awful moment had come, pronounced the spell of incantation taught her by the mountain spirit, and raised her T-shaped wand. In a moment her fair head and lovely face, body, limbs and feet lengthened out, disappeared, or became demon-like, and a fire-darting, hissing-tongued serpent, with eyes like moons trailed over the ground towards the temple, swam the river, and scenting out the track of the fugitive, entered the belfry, cracking the supporting columns made of whole tree-trunks into a mass of ruins, while the bell fell to the earth with the cowering victim inside.

Then began the winding of the terrible coils round and round the metal, as with her wand of sorcery in her hands, she mounted the bell. The glistening scales, hard as iron, struck off sparks as the pressure increased. Tighter and tighter they were drawn, till the heat of the friction consumed the timbers and made the metal glow hot like fire.

Vain was the prayer of priest, or spell of rosary, as the bonzes piteously besought great Buddha to destroy the demon. Hotter and hotter grew the mass, until the ponderous metal melted down into a hissing pool of scintillating molten bronze; and soon, man within and serpent without, timber and tiles and ropes were nought but a few handfuls of white ashes.

ILLUSTRATIONS
Page 30: Kiyohime and the bell; art by Kunisada (c.1850).
Page 31: Kiyohime at Hidaka River; art by Nobukazu (c.1885).
Page 34: Kiyohime and the bell; art by Kuniyoshi (c.1845).

TAMETOMO THE ARCHER

Long, long ago there lived in Japan a man named Hachiro Tametomo, who became famous as the most skilful archer in the whole of the realm at that time. *Hachiro* means "the eighth," and he was so called because he was the eighth son of his father, General Tameyoshi of the house of Minamoto. Yoshitomo, who afterwards became such a great figure in Japanese history, was his elder brother. Tametomo was therefore uncle to the Shogun Yoritomo and the hero Yoshitsune. He belonged to an illustrious family indeed.

As a child Hachiro gave promise of being a very strong man, and as he grew older this promise was more than fulfilled. He early showed a love of archery, and his left arm being four inches longer than his right, there was no one who could bend the bow better or send the arrow farther than he could. By nature Hachiro was a rough, wild boy who did not know what fear was, and he loved to challenge his elder brothers to fight. He ever grew wilder as he grew older, till at last he acted so rudely and wilfully, respecting and obeying no one set over him, that even his own father found him unmanageable.

Now it happened when Hachiro was thirteen years old that a learned man, named Fujiwara-no-Shinsei,

came to the Palace of the Emperor one day to give a lecture on a certain book. During the lecture he said that there could not be found in the whole of Japan a warrior whose skill in archery could match that of Kiyomori, the chief of the Taira clan, or of Yorimasa, the Minamoto knight. These two knights, though belonging to two different clans, were the best archers throughout the land. Now Hachiro, when he heard these words, laughed aloud in scorn, and said, so that every one might hear him, that Fujiwara-no-Shinsei was right about Yorimasa, but to call their enemy, that coward of a Kiyomori, a clever archer, only showed what a foolish and ignorant man Fujiwara-no-Shinsei was.

This rude speech, so contrary to the rules of Japanese courtesy, which commands young people to maintain a respectful and humble silence in the presence of their elders, made Fujiwara very angry. When the lecture was finished, he therefore sent for Tametomo and rebuked him sternly for his behaviour, but the daring Tametomo, instead of being ashamed of his unmannerly conduct and prostrating himself in apology before the learned man, would not listen to anything he had to say, and was so boisterous in declaring that he was right that Fujiwara gave up his task of correction as a hopeless one.

But the lad's father, Tameyoshi, when he heard of what had happened, was very angry with his son for daring to dispute with his elder and superior, especially in the sacred precincts of the Palace. He was so wroth indeed that at last he refused to see him or to keep him any longer under his roof, and to punish him he sent him far away from his home to the island of Kiushiu.

Now Tametomo, like the wilful, headstrong boy that he was, did not mind his banishment at all; on the contrary, he felt like a hound let loose from the leash, and rejoiced in his liberty, even though he had incurred his father's displeasure.

When he reached the island of Kiushiu he made his way to the province of Higo, and finally settled down in the plain of Kumamoto. Now that Tametomo found himself free to do just as he liked, his thirst for conflict became so great that he could not restrain himself. He gathered round him a band of fighters as wild as himself and challenged the men in all the neighbouring provinces to come out and match their strength against his. In twenty battles which followed this challenge Tametomo was never once defeated, so great was his strength, and his cleverness in directing his soldiers. He was like a silkworm eating up the mulberry tree. Just as the silkworm devours one leaf after another, with slow but sure relentlessness, so Tametomo fought and fought the inhabitants of the provinces round about till he had brought them all into subjection under him. By the time he was eighteen years old he had made himself chief of a large band of outlaws, distinguished for their reckless bravery, and with them he had mastered the whole of Kiushiu, the western part of Japan. It was now that the name of Chin-sei was given him on account of his having conquered the West. *Chin* means "to put down," and *sei* means the "West."

Tidings travelled slowly in those days, for there were no railways or telegraph wires forming a network of lightning speed communication across the land, and all carrying of news was done on foot by messengers; so it was a long time before the Government at the capital heard of the wild and lawless doings of Chinsei Hachiro Tametomo, but at last his daring exploits became known, and the Government decided to interfere and to put a stop to his outlawry. They sent a regiment, of soldiers to hunt him down and take him prisoner, but Tametomo and his band were not only strong and fearless, but sharp of wit, and in the frequent skirmishes that took place they always came out victorious. At last the soldiers gave up their task of capturing him, for they found it impossible to overcome him and nothing would make Tametomo surrender. So the general returned to the capital and confessed that his expedition had failed. The Government now decided to arrest the outlaw's father, Tameyoshi, and so try to bring the rebel to bay. Tameyoshi was therefore seized and punished for being the parent of such an incorrigible rebel.

Now even the wilful Tametomo was moved and distressed when he heard of what had happened to his father,

because of him. Although he was undisciplined by nature, and ever ready to rebel against all authority, yet hidden deep in his heart there was still a sense of duty to his father, and on this his enemies had counted. He knew that it was inexcusable to let his father suffer punishment for his misdoings. As soon as the bad tidings reached him, he gave up without the least hesitation all the land in Kiushiu, which had cost him several years of hard fighting to wrest from the inhabitants, and taking with him only ten of his men, with all the speed he could make, he went up to the capital.

As soon as he reached the city he sent in a document signed and sealed in his blood, asking pardon of the Government for all his former offences, and begging that his father might be released at once. He then waited calmly and quietly for his sentence of punishment to be declared.

Now when those in authority saw his filial piety and his good conduct at this crisis, they could not find it in their hearts to treat him with severity.

"Even this man who has behaved like a demon can feel so much for his father," they exclaimed; and merely rebuking him for his lawlessness they handed him over to his father, whom they had set free.

At this time civil war broke out in the land, for two brothers, sons of the late ex-Emperor Toba, aspired to sit on the Imperial throne. Owing to the favouritism of their father the elder brother, Sutoku, was forced to abdicate and retire, while Go-Shirakawa, the younger brother, was put on the throne. On his deathbed the ex-Emperor Toba (also called the Pontiff-Emperor) had foreseen that there would be strife between the two, and left sealed instructions in case of emergency. On opening this document it was found to contain a command to all the principal generals to support Go-Shirakawa.

Hence the great chief of the Taira, Kiyomori, and Tametomo's eldest brother, Yoshitomo – indeed all the warriors of repute and strength – supported Go-Shirakawa, while such nobles as Yorinaga and Fujiwara-no-Shinsei, who knew nothing of fighting, sided with the retired Emperor Sutoku. Yorinaga, it is said, could not mount his horse. Indeed the only efficient soldiers on Sutoku's side were Tameyoshi and his seven younger sons, Tametomo, the reformed rebel, amongst them. Sutoku was told of Tametomo's strength and wonderful skill as an archer, and was advised to make use of him, so Tametomo was summoned ere long to the ex-Emperor's presence.

Tametomo was now just twenty years of age; he was more than seven feet in height; his eyes were sharp and piercing like those of a hawk, and he carried himself with great pride and noble bearing. As he entered the Imperial Audience Hall, so strong and brave and such a fine soldier did he look, that Sutoku at once felt confidence in him, and without delay consulted the young knight about the impending war.

Then Tametomo told the Emperor of how, when he had been banished to the West by his father, he had lived the life of an outlaw for many years – all that time his hand had been raised against every one, and every one had fought against him. It had been his delight and pastime to fight all who opposed his being lord of Kiushiu. He and his band had always conquered, he said, because they had always fought at night. It would be a good plan, he thought, for Sutoku and his men to attack the Palace of Go-Shirakawa by night, to set fire to the Palace on three sides and to place soldiers on the fourth side to seize the new Emperor and his party when they tried to escape. If the ex-Emperor would follow his advice, Tametomo said he felt sure that he would win the victory.

Yorinaga, who was attending the Council when he heard Tametomo's plan, shook his head in disapproval, and said that Tametomo's scheme of attack was an inferior one; that in his opinion it was a coward's trick to attack by night; and that it was more befitting brave soldiers to fight by day in the ordinary way.

When Tametomo saw that his advice was overruled and that Sutoku's Council would not follow his tactics, he left the Palace. When he reached home he told his men of all that had passed, and added in his anger that Yorinaga was a conceited fellow who knew nothing of fighting, though he had dared to give his worthless opinion and to

contradict him, Tametomo, who had fought without once being beaten all his life long. Thus giving vent to his disappointment, Tametomo seated himself on the mats, and as his anger passed away, he added with a sigh: "I only fear that Sutoku will be defeated in the coming struggle!"

Had Tametomo's tactics been followed, Japanese history would certainly have been different, for Kiyomori and Yoshitomo won a victory by the very plan which Tametomo had advised Sutoku to follow. That night, without any warning, the enemy made an attack on the ex-Emperor's Palace.

The wary Tametomo, however, expected an assault and had stationed himself at the South Gate on guard. On seeing Kiyomori and his band approaching he exclaimed: "You feeble worms! I'll surprise you!" and taking his bow and arrow shot a samurai named Ito Roku through the breast. The arrow was shot with such skill and force that it went right through the soldier's body, and coming out through his back, pierced the sleeve of the armour of Ito Go, his younger brother, who was riding close behind him.

Ito Go, when he saw the precision and strength with which the arrow was shot, knew that they had to deal with no common foe, and in alarm carried the arrow to his general, Kiyomori, to show it to him. Kiyomori examined the arrow carefully and found that it was made from a strong bamboo of more than the usual thickness, and that the metal head was like a big chisel, a formidable weapon indeed! It was so large that it resembled a spear more than an arrow, and even the redoubtable Kiyomori trembled at the sight of it.

"This looks more like the arrow of a demon than of a man. Let us find another place of assault where our enemies are weaker and where the leaders are not such remarkable marksmen!" said he.

Kiyomori then retired from the attack on the South Gate.

When Yoshitomo (who was now supporting Kiyomori, though later on he left the Taira chief) heard of his brother Tametomo's doings, he said: "Tametomo may be a daredevil and boast of his skill as an archer, but he will surely not take up his bow and arrow against the person of his elder brother," and he took Kiyomori's place at the South Gate of the Palace which Tametomo was guarding.

Drawing near the great roofed gate, Yoshitomo called aloud to Tametomo and said: "Is that you, Tametomo, on guard there? What a wicked deed you commit to fight against your elder brother? Now quickly open the gate and let me in. Tametomo! Do you hear? I am Yoshitomo! Retire there!"

Tametomo laughed aloud at his elder brother's command and answered boldly: "If it is wrong for me to take up arms against you, my brother, are you not an undutiful son to take up arms against your father?" (Tameyoshi, his father, was fighting on the ex-Emperor's side.)

Yoshitomo had no words wherewith to answer his brother and was silent. Tametomo, with his archer's eye, saw what a good mark his brother made just outside the gate, and he was greatly tempted to shoot at him even for sport. But he said that though war found them fighting on opposite sides, yet they were brothers, born of the same mother, and that it would be acting against his conscience to kill or hurt his own brother, for surely he would do so if he took aim seriously! He would however for the sake and love of sport continue to show Yoshitomo what a clever marksman he was. Taking good aim at Yoshitomo's helmet, Tametomo raised his bow and shot an arrow right into the middle of the star that topped it. The arrow pierced the star, came out the other side, and then cut through a wooden gate five or six inches in thickness.

Even Yoshitomo was astonished at the skill which his brother displayed by this feat of archery. He now led his soldiers forward to the attack.

But Sutoku's army was far outnumbered by the enemy, who swept down upon the Palace in overwhelming numbers, and though Tametomo fought bravely and with great skill, his strength and valour were of no avail against

the great odds which assailed him. The enemy gained ground slowly, inch by inch, till at last the gates were battered down, and they ruthlessly entered the Palace. Calamity was added to calamity, the foe set fire to several parts of the building, and great confusion ensued.

The ex-Emperor, in making a vain attempt to escape with Yorinaga, was caught and taken prisoner. Seeing that for the present there was nothing to be done, Tametomo, with his father Tameyoshi and his other brothers, all loyal to Sutoku's cause, made good their escape and fled to the province of Omi.

Tameyoshi was an old man unable to endure the hardships of a hunted life, and he found that he could go no further; so he told his sons that, as the Emperor had been taken prisoner, and as there was no hope of raising Sutoku's flag again, at any rate for the present, it would be wiser for them all to return to the capital and surrender themselves to the conquerors – the Taira. They all agreed to this proposal except Tametomo, so Tameyoshi, the aged general, and the rest of his sons went back to Kyoto.

Now Tametomo was left behind, alone in his brave resolution to fight another battle for the ex-Emperor Sutoku. As soon as he had parted, sad and determined, from his father and brothers, he made his way towards the Eastern provinces. But unfortunately, as he was journeying, the wound he had received in the recent fight became so painful that he stopped at some springs along the route, with the hope that the healing waters, a panacea for so many ills in Japan, would heal his hurt. But while taking the cure, his enemies came upon him and made him prisoner and he was sent back a captive to the capital.

By the time Tametomo reached the city, his father and his brothers had been put to death, and he was soon told that he was to meet the same cruel fate.

But courage always arouses chivalry in the hearts of friends and foes alike, and it seemed to Tametomo's enemies a pity to put such a brave man to death. In the whole land there was no man who could match him in bending the bow and sending the arrow home to its mark, so it was decided to spare his life at the last moment. But to prevent him from using his wonderful skill against them, his enemies cut the sinews of both his arms and sent him away to the island of Oshima off the coast of the province of Jdzu to live. Lest he should escape on the way they bound him hand and foot and put him in a palanquin. He was surrounded by a guard of fifty men, and so big and heavy was he that

twenty bearers were required to carry the palanquin.

In spite of all the misfortunes that had befallen him, he carried the same courage, the same stout merry heart, the same love of wildness with him, even into exile. As the twenty men carried him along in the palanquin, Tametomo just for fun would now and again put forth all his strength. So great was his weight then that the twenty bearers would stagger and fall to the ground. These feats of strength alarmed the escort of fifty soldiers. They feared lest he should act more savagely and become unmanageable, past their power of control, so they treated him in much the same way as they would have treated a lion or a tiger. They tried not to anger him, but did their utmost to keep him in a good humour during the journey.

At last they reached the province of Idzu and the seashore from whence they had to cross over to the island. Here they hired a boat, and putting Tametomo safely on board they took him to his last destination and left him there.

Though Tametomo was banished to this island, yet once there his enemies left him free to do much as he liked. He was not treated as a common prisoner, but as a brave though vanquished foe. The simple islanders recognized in him a great man and behaved to him accordingly and listened to everything he chose to say. So he led an unmolested life, free from care, except the sorrow of being an exile – but his was a nature which took life as it came, without worrying about what he could not help.

Now one day Tametomo was standing on the beach gazing out to sea, thinking of the many adventures he had passed through and wondering if fate would ever bring any change in the quiet life he was leading, when he saw a sea-gull come flying over the water. At first Tametomo with his keen, eyes saw only a speck in the distance, but the speck grew larger and larger till at last the seabird appeared. Tametomo now guessed that there was an island lying in the direction from which the bird came. So he got into a boat and set out on a voyage of discovery.

As he expected, he came to an island, after sailing from sunrise to sundown. To his amazement he found the place inhabited by creatures very different from human beings. They had dark red faces, with shocks of bright red hair, the locks of which hung over their foreheads and eyes. They looked just like demons. A whole crowd of these alarming-looking creatures were standing on the beach when Tametomo landed. When they caught sight of him they talked and gesticulated wildly amongst themselves and with fierce looks they rushed towards him.

Tametomo saw at once that they meant him harm, but he was nothing daunted. He went up to a large pine tree that was growing near by, laid his hands on it, and uprooting it with as much ease as if it were a weed, he brandished it over his head and called aloud threateningly: "Come, you demons, fight if you will. I am Chinsei Hachiro Tametomo, the Archer of great Japan. If you will henceforth become my servants and look up to me as master in all things, it is well; otherwise I will beat you all to little pieces."

When the demons saw Tametomo's great strength and his fearlessness they trembled. They held a short parley amongst themselves, and then the demon chief stepped forward, followed by all his band. They came in front of Tametomo and prostrating themselves before him on the sand, they one and all surrendered. Tametomo with much pride took possession of this island of demons and made himself monarch of all he surveyed. Having subdued the demons he returned to Oshima with the news. Great was the praise and merit awarded him by all the islanders for this act of great bravery.

Another day, soon after this, Tametomo was walking along the sands of the seashore, when he saw coming towards him, floating nearer and nearer on the top of the waves, a little old man. Tametomo could hardly believe his sight; he had never seen anything so strange in his whole life; he rubbed his eyes, thinking he must be dreaming, and looked and looked again. There sure enough was a tiny man, no bigger than one foot five inches high, sitting gracefully on a round straw mat.

Filled with wonder, Tametomo walked to the edge of the sand, and as the little creature floated nearer on an incoming wave he said: "Who are you?"

"I am the microbe of small-pox," answered the stranger pigmy.

"And why, may I ask, do you come to this island?" inquired Tametomo.

"I have never been here before, so I came partly for sightseeing and partly with the desire to seize hold of the inhabitants," answered the little creature.

Before he could finish his sentence Tametomo said angrily: "You spirit of hateful pestilence! Silence, I say! I am no other than Chinsei Hachiro Tametomo! Get out of my presence at once and take yourself far from this place, or I will make you repent the day you ever came here!"

As Tametomo spoke, the small-pox microbe shrank and shrank from the form of a tiny man one foot five inches high, till only something the size of a pea was left in the middle of the straw mat. As he dwindled and dwindled, the little creature said that he was sorry that he had intruded into the island, but he had not known that it was in Tametomo's possession; and he then floated away out to sea on his straw mat as quickly and mysteriously as he had come.

The island of Oshima has always been free from small-pox, and to this day the islanders ascribe the immunity they enjoy from the horrible pestilence to Tametomo, who drove away the microbe when the hateful creature would have landed there.

Now that Tametomo had subdued the demons on the neighbouring island and had driven away the spirit of small-pox from Oshima, he was looked upon as a king by the simple islanders. They rendered him every possible honour and bowed their heads in the dust before him whenever he went abroad.

At last this state of affairs was reported to the authorities in the capital. The Ministers of State decided that it was unsafe to allow this to go on. Such a popular and powerful hero was a menace to the Government. Tametomo, the Champion Archer, must be put down and without delay. Such was the decree. A messenger was then and there despatched with sealed orders to Minamoto no Mochimitsu, in Idzu, to set sail with his men for Oshima and subdue Tametomo.

One day Tametomo was standing on the beach and watching with pleasure, as he often did, the ever-whispering sea laughing and sparkling in the sunshine, when he saw fifty warjunks coming towards the island. The soldiers standing on the fifty decks were all armed with swords and bows and arrows, and clad in armour from head to foot, and they were beating drums and singing martial songs. Tametomo smiled when he saw this fleet all mustered in martial array and sent against him, a single man, for he knew, somehow or other, what they had come for.

"Now," he said proudly to himself, "the opportunity is given me of trying my archer's skill once more." Seizing his bow, he pulled it to the shape of a full moon, and aiming it at the foremost ship, sent an arrow right into the prow. In an instant the boat was upset and the soldiers pitched into the sea.

Till that moment Tametomo had feared that his arm had lost its first great strength, since his enemies had cut the sinews; but on the contrary he now found that not only were his arms as strong as ever, but that they had even grown longer, and that lie was able to pull his bow wider than before. He clapped his hands with joy at the discovery and called aloud: "This is a happy thing!"

But now Tametomo reflected that if he fought against those who had been sent by the Government to take him, he would only bring trouble on the people of the island, who had been so kind to him and who had sheltered him in his exile; he thought of how in their simple reverence for his great strength they had almost worshipped him as a deified hero and had looked up to him as their leader. No, he would not, could not, bring war and trouble and certain punishment upon these good folk, so for their sake he decided not to fight more. He looked back with the keen flight of thought that comes to mortals in moments of great crises, and he remembered how with special mercy his life had been spared when he was taken prisoner in the civil war. Since then he had enjoyed life for over ten years. As a strong, brave man he could not grudge losing it now. He had made himself owner of the islands and the people called him their king; he felt that there was no shame or regret in dying when he had reached the height of his glory. Therefore, with firm and quick decision he made up his mind to die. He withdrew at once from the beach and retired to his house, and here he committed suicide by harakiri, thus saving himself from all dishonour and the islanders from all trouble. He was only thirty-two years of age when he died. His death was greatly regretted by all who loved him. But his glory did not die with him. The people ever afterward honoured and reverenced him as a great hero.

Such is one story of the death of Tametomo, but legend has created another, still more interesting, about him. Instead of taking his own life, this tradition says that he escaped from Oshima and reached Sanuki. Here he visited the late Emperor's tomb and offered up prayers for the illustrious dead. He then, believing that his day of usefulness was over, prepared to kill himself, when suddenly, as in a dream, the Emperor, Yorinaga, his father, and all those royalists who had fought and died in the civil war, or had been taken prisoners and killed by the victorious parties of the new Emperor, appeared to him in the clouds and with a warning gesture prevented him from committing the dread deed of harakiri. As Tametomo gazed wonderingly at the beautiful vision, the bamboo curtain which hung before the ex-Emperor's palanquin lifted, and as the sunshine and grace of His Majesty's smile fell upon the awestricken man, the sword dropped from his hand and the wish to die expired in his breast. He fell forward in humble prostration to the ground. When Tametomo lifted his head, the vision had vanished within the clouds; nothing remained to be seen of the royal array which had saved him from his self-imposed death.

This wonderful visitation changed Tametomo's mind. He gave up all idea of seeking death, and, leaving Sanuki, journeyed to Kiushiu, and took up his abode on Mount Kihara. Here he collected a band of followers, and with them embarked on board a ship with the intention of reaching the capital and once more striking a blow at the

arrogant and usurping House of Taira. But misfortune followed him. He was overtaken by a storm, his ship was wrecked, his men lost, while he only narrowly escaped with his life to the island of Riukiu. Here he found the people in a state of great excitement, for a party of rebels had risen against the King, who was greatly oppressed by them. Tametomo put himself at the head of the loyalists, rescued the King, who had been taken prisoner, subdued the rebels, and then restored peace to the disturbed land. For these meritorious services the King adopted him as his son, bestowed upon him the title of Prince, and married him to one of the royal Princesses. At last one day, when Tametomo had reached a good old age, happy in the life of peace and bliss with which his later years had been crowned, as he was walking along one of the spacious verandahs of the Palace, his attendants noticed a trail of cloud coming towards their master from the sky. As soon as the cloud touched Tametomo, he began to rise in the air before their astonished gaze. Lost in speechless amazement, they watched the hero mount higher and higher, till the clouds closed round him and hid him from their view. Such is the pretty legend of the earthly end of the brave archer Tametomo, one of the most interesting figures in Japanese history, who conquered the trials and misfortunes of his youth, and won through to bright days of prosperity. He left a son called Shun-Teimo, who became King of Riukiu in due time.

ILLUSTRATIONS
Page 36: Tametomo and two demons (detail); art by Kunisada (c.1820).
Page 37: Tametomo, from the series **A Mirror Of Strange Tales From China And Japan**; art by Yoshitoshi (1880).
Page 38: Tametomo at the age of thirteen, from the series **Ten Famous Excellences Of Tametomo**; art by Kuniyoshi (c.1850).
Page 41: Tametomo and two fighting wolf-cubs, from the series **Ten Famous Excellences Of Tametomo**; art by Kuniyoshi (c.1850).
Page 42: Tametomo sees an apparition of his father, from the series **Ten Famous Excellences Of Tametomo**; art by Kuniyoshi (c.1850).
Page 44: Magic battle, from the series **Ten Heroes Of Tametomo**; art by Yoshitsuya (1858).
Page 45: Magic battle, from the series **Ten Heroes Of Tametomo**; art by Yoshitsuya (1858).
Page 46: Tametomo subjugates the smallpox demon, from the series **Mirror Of Japanese Heroes**; art by Yoshimori (1856).
Page 47: Tametomo sinking the lead ship of Minamoto no Mochimitsu's fleet (triptych panel); art by Kuniyoshi (c.1852).
Page 51: Tametomo is deterred from suicide by a vision of Sutoku, from the series **Ten Famous Excellences Of Tametomo**; art by Kuniyoshi (c.1850).

THE STORY OF A TENGU

In the days of the Emperor Go-Reizei, there was a holy priest living in the temple of Saito, on the mountain called Hiyei-Zan, near Kyoto. One summer day this good priest, after a visit to the city, was returning to his temple by way of Kita-no-Oji, when he saw some boys ill-treating a kite. They had caught the bird in a snare, and were beating it with sticks. "Oh, the, poor creature!" compassionately exclaimed the priest; "why do you torment it so, children?"

One of the boys made answer: "We want to kill it to get the feathers."

Moved by pity, the priest persuaded the boys to let him have the kite in exchange for a fan that he was carrying; and he set the bird free. It had not been seriously hurt, and was able to fly away.

Happy at having performed this Buddhist act of merit, the priest then resumed his walk. He had not proceeded very far when he saw a strange monk come out of a bamboo-grove by the road-side, and hasten towards him. The monk respectfully saluted him, and said: "Sir, through your compassionate kindness my life has been saved; and I now desire to express my gratitude in a fitting manner."

Astonished at hearing himself thus addressed, the priest replied: "Really, I cannot remember to have ever seen you before: please tell me who you are."

"It is not wonderful that you cannot recognize me in this form," returned the monk; "I am the kite that those cruel boys were tormenting at Kita-no-Oji. You saved my life; and there is nothing in this world more precious than life. So I now wish to return your kindness in some way or other. If there be anything that you would like to have, or to know, or to see – anything that I can do for you, in short – please to tell me; for as I happen to possess, in a small degree, the Six Supernatural Powers, I am able to gratify almost any wish that you can express."

On hearing these words, the priest knew that he was speaking with a Tengu; and he frankly made answer: "My friend, I have long ceased to care for the things of this world: I am now seventy years of age; neither fame nor pleasure has any attraction for me. I feel anxious only about my future birth; but as that is a matter in which no one can help me, it were useless to ask about it. Really, I can think of but one thing worth wishing for. It has been my life-long regret that I was not in India in the time of the Lord Buddha, and could not attend the great assembly on the holy mountain Gridhrakuta. Never a day passes in which this regret does not come to me, in the hour of morning or of evening prayer. Ah, my friend! if it were possible to conquer Time and Space, like the Bodhisattvas, so that I could look upon that marvellous assembly, how happy should I be!"

"Why," the Tengu exclaimed, "that pious wish of yours can easily be satisfied. I perfectly well remember the assembly on the Vulture Peak; and I can cause everything that happened there to reappear before you, exactly as it occurred. It is our greatest delight to represent such holy matters…. Come this way with me!"

And the priest suffered himself to be led to a place among pines, on the slope of a hill. "Now," said the Tengu, "you have only to wait here for awhile, with your eyes shut. Do not open them until you hear the voice of the Buddha preaching the Law. Then you can look. But when you see the appearance of the Buddha, you must not allow your devout feelings to influence you in any way; you must not bow down, nor pray, nor utter any such exclamation as, 'Even so, Lord!' or 'O thou Blessed One!' You must not speak at all. Should you make even the least sign of reverence, something very unfortunate might happen to me."

The priest gladly promised to follow these injunctions; and the Tengu hurried away as if to prepare the spectacle. The day waned and passed, and the darkness came; but the old priest waited patiently beneath a tree, keeping his eyes closed. At last a voice suddenly resounded above him, a wonderful voice, deep and clear like the pealing of a mighty bell, the voice of the Buddha Sakyamuni proclaiming the Perfect Way. Then the priest, opening his eyes in a great radiance, perceived that all things had been changed: the place was indeed the Vulture Peak, the holy Indian mountain Gridhrakuta; and the time was the time of the Sutra of the Lotos of the Good Law. Now there were no pines about him, but strange shining trees made of the Seven Precious Substances, with foliage and fruit of gems; and the ground was covered with Mandarava and Manjushaka flowers showered from heaven; and the night was filled with fragrance and splendour and the sweetness of the great Voice. And in mid-air, shining as a moon above the world, the priest beheld the Blessed One seated upon the Lion-throne, with Samantabhadra at his right hand, and Manjusri at his left, and before them assembled – immeasurably spreading into Space, like a flood Of stars – the hosts of the Mahasattvas and the Bodhisattvas with their countless following: "gods, demons, Nagas, goblins, men, and beings not human." Sariputra he saw, and Kasyapa, and Ananda, with all the disciples of the Tathagata, and the Kings of the Devas, and the Kings of the Four Directions, like pillars of fire, and the great Dragon-Kings, and the Gandharvas and Garudas, and the Gods of the Sun and the Moon and the Wind, and the shining myriads of Brahma's heaven. And incomparably further than even the measureless circling of the glory of these, he saw – made visible by a single ray of light that shot from the forehead of the Blessed One to pierce beyond uttermost Time – the eighteen hundred thousand Buddha-fields of the Eastern Quarter with all their habitants, and the beings in each of the Six States of Existence, and even the shapes of the Buddhas extinct, that had entered into Nirvana. These, and all the gods, and all the demons, he saw bow down before the Lion-throne; and he heard that multitude incalculable of beings praising the Sutra of the Lotos of the Good Law, like the roar of a sea before the Lord.

Then forgetting utterly his pledge, foolishly dreaming that he stood in the very presence of the very Buddha, he cast himself down in worship with tears of love and thanksgiving; crying out with a loud voice, "O thou Blessed One!"…

Instantly with a shock as of earthquake the stupendous spectacle disappeared; and the priest found himself alone in the dark, kneeling upon the grass of the mountain-side. Then a sadness unspeakable fell upon him, because of the loss of the vision, and because of the thoughtlessness that had caused him to break his word. As he sorrowfully turned his steps homeward, the goblin-monk once more appeared before him, and said to him in tones of reproach and pain: "Because you did not keep the promise which you made to me, and heedlessly allowed your feelings to overcome you, the Gohotendo, who is the Guardian of the Doctrine, swooped down suddenly from heaven upon us, and smote us in great anger, crying out, 'How do ye dare thus to deceive a pious person?' Then the other monks, whom I had assembled, all fled in fear. As for myself, one of my wings has been broken, so that now I cannot fly." And with these words the Tengu vanished forever.

ILLUSTRATIONS
Page 52: Keyamura Rokusuke performing devotions under a waterfall, watched by two tengu; art by Kuniyoshi (c.1842).Page
Page 55: Hojo Takatoki tormented by tengu; art by Yoshitoshi, from the series **Yoshitoshi's Courageous Warriors** (1883).

THE GHOST OF OIWA

In the Edo Period of Japan, there lived a masterless *samurai* named Iemon. He and his wife, Oiwa, lived in Tokyo. Oiwa was happily expecting a baby, and loved her husband very much. Oiwa didn't care that Iemon was poor, but he was depressed about his lack of prospects anyway.

A rich young woman named Oume fell in love with Iemon despite his poverty and marital status, and one day her grandfather came to Iemon. He told Iemon what a shame it was that he was already married, because his granddaughter loved him very much. The grandfather went on to say all the ways that he would ensure his granddaughter's future husband's wealth and success. Iemon listened intently.

After some time thinking about the grandfather's visit, Iemon decided to free himself of Oiwa and their unborn child so that he could marry Oume. The easiest way to do this was to poison Oiwa. Oiwa, ignorant of Iemon's plans, happily prepared for the arrival of their baby.

One evening Oiwa and Iemon sat down to dinner, and Oiwa noticed her husband was strangely quiet and listless. She encouraged him to eat, but he would not touch his food. He encouraged Oiwa to stop fretting and to eat, herself. She needed to be strong for the baby, after all. Oiwa finally gave up trying to tempt Iemon's appetite and started to eat. It wasn't long before she felt very sick.

Iemon watched her coldly as the poison did its work, not offering her any help or comfort. But Oiwa did not die right away. Her beautiful face became disfigured from the poison first. Then she slipped into unconsciousness. Iemon was too much of a coward to finish the job he started, so he put Oiwa's lifeless body in bed. Eventually Oiwa woke from her coma, remembering nothing of the poisoning. She had lost her baby, and her face was ugly and terrible, but Oiwa lived. When she combed her hair, it fell out in bloody clumps.

Iemon was desperate. He played the part of the concerned husband, but he was looking for any way possible to rid himself of his wife. One evening he took Oiwa for a long walk. They made their way to a cliff, and Iemon looked around to see if anyone was nearby. No one was in sight.

Iemon pushed Oiwa off the ledge. Her broken body was recovered and Iemon gave her the best funeral he could afford, spending all of his money in a great show of marital devotion. Of course, Iemon knew his money troubles were only temporary now that Oiwa was gone.

Thinking his worries were over, Iemon planned his wedding to Oume. The night before the marriage was to take place, Iemon noticed his lamp was dimming. He looked at it curiously, as it seemed to be changing. The disfigured face of Oiwa suddenly replaced the lamp, growing larger and larger in the room. "Betrayal!" it hissed.

Iemon grabbed his katana and swung at the face, but Oiwa disappeared and the lamp fell to the floor, cut from its cord. Iemon thought he heard the faint laughter of a woman from outside. Shaken, Iemon stamped out the lamp's candle that was now burning the rug. He soon convinced himself that the vision was simply the result of too much sake earlier in the evening, and went to bed.

The next day, Iemon had forgotten all about the specter from the night before. He and Oume were wed. When he lifted her veil, however, her beautiful young face was replaced with Oiwa's horrible visage. "Betrayal!" she hissed.

Iemon once again defended himself with his sword, cutting Oiwa's head off. When it landed on the floor, however, it had Oume's face and not Oiwa's. He heard the faint sound of laughter again.

Iemon ran to his tiny house, looking for a place to hide. There was a pounding at the door, and Oume's grandfather demanded that he open it. When Iemon did so, Oiwa was standing there. "Betrayal!" she hissed.

Once again, Iemon tried to decapitate her, but when his sword finished its work, it was Oume's grandfather that lay dead.

Iemon ran for the cliffs, Oiwa's laughter following him. He stopped at the edge and looked down, perhaps changing his mind.

It didn't matter. Passersby reported seeing a woman push Iemon off the cliff before she jumped after him, laughing all the way down.

ILLUSTRATIONS
Page 56: Oiwa's hair falls out in bloody clumps; art by Kuniyoshi (1847)
Page 57; Oiwa's hair falls out in bloody clumps; art by Toyokuni I (c.1830).
Page 58: The ghost of Kasane (an alternative version of Oiwa) descending, from the series **Comparisons For 36 Selected Poems**; art by Kunisada (1852).

THE LEGEND OF MOMOTARO

Long, long ago there lived, an old man and. an old woman; they were peasants, and had to work hard to earn their daily rice. The old man used to go and cut grass for the farmers around, and while he was gone the old woman, his wife, did the work of the house and worked in their own little rice field.

One day the old man went to the hills as usual to cut grass and the old woman took some clothes to the river to wash. It was nearly summer, and the country was very beautiful to see in its fresh greenness as the two old people went on their way to work. The grass on the banks of the river looked like emerald velvet, and the pussy willows along the edge of the water were shaking out their soft tassels. The breezes blew and ruffled the smooth surface of the water into wavelets, and passing on touched the cheeks of the old couple who, for some reason they could not explain, felt very happy that morning.

The old woman at last found a nice spot by the river bank and put her basket down. Then she set to work to wash the clothes; she took them one by one out of the basket and washed them in the river and rubbed them on the stones. The water was as clear as crystal, and she could see the tiny fish swimming to and fro, and the pebbles at the bottom. As she was busy washing her clothes a great peach came bumping down the stream. The old woman looked up from her work and saw this large peach. She was sixty years of age, yet in all her life she had never seen such a big peach as this.

"How delicious that peach must be!" she said to herself. "I must certainly get it and take it home to my old man."

She stretched out her arm to try and get it, but it was quite out of her reach. She looked about for a stick, but there was not one to be seen, and if she went to look for one she would lose the peach.

Stopping a moment to think what she would do, she remembered an old charm-verse. Now she began to clap her hands to keep time to the rolling of the peach down stream, and while she clapped she sang this song:

"Distant water is bitter,
The near water is sweet;
Pass by the distant water
And come into the sweet."

Strange to say, as soon as she began to repeat this little song the peach began to come nearer and nearer the bank where the old woman was standing, till at last it stopped just in front of her so that she was able to take it up in her hands. The old woman was delighted. She could not go on with her work, so happy and excited was she, so she put all the clothes back in her bamboo basket, and with the basket on her back and the peach in her hand she hurried homewards.

It seemed a very long time to her to wait till her husband returned. The old man at last came back as the sun was setting, with a big bundle of grass on his back--so big that he was almost hidden and she could hardly see him. He seemed very tired and used the scythe for a walking stick, leaning on it as he walked along. As soon as the old woman saw him she called out:

"O Fii San! (old man) I have been waiting for you to come home for such a long time to-day!"

"What is the matter? Why are you so impatient?" asked the old man, wondering at her unusual eagerness. "Has anything happened while I have been away?"

"Oh, no!" answered the old woman, "nothing has happened, only I have found a nice present for you!"

"That is good," said the old man. He then washed his feet in a basin of water and stepped up to the veranda.

The old woman now ran into the little room and brought out from the cupboard the big peach. It felt even heavier than before. She held it up to him, saying:

"Just look at this! Did you ever see such a large peach in all your life?"

When the old man looked at the peach he was greatly astonished and said:

"This is indeed the largest peach I have ever seen! Wherever did you buy it?"

"I did not buy it," answered the old woman. "I found it in the river where I was washing." And she told him the whole story.

"I am very glad that you have found it. Let us eat it now, for I am hungry," said the O Fii San.

He brought out the kitchen knife, and, placing the peach on a board, was about to cut it when, wonderful to tell, the peach split in two of itself and a clear voice said:

"Wait a bit, old man!" and out stepped a beautiful little child.

The old man and his wife were both so astonished at what they saw that they fell to the ground. The child spoke again:

"Don't be afraid. I am no demon or fairy. I will tell you the truth. Heaven has had compassion on you. Every day and every night you have lamented that you had no child. Your cry has been heard and I am sent to be the son of your old age!"

On hearing this the old man and his wife were very happy. They had cried night and day for sorrow at having no child to help them in their lonely old age, and now that their prayer was answered they were so lost with joy that they did not know where to put their hands or their feet. First the old man took the child up in his arms, and then the old woman did the same; and they named him MOMOTARO, OR SON OF A PEACH, because he had come out of a peach.

The years passed quickly by and the child grew to be fifteen years of age. He was taller and far stronger than any other boys of his own age, he had a handsome face and a heart full of courage, and he was very wise for

his years. The old couple's pleasure was very great when they looked at him, for he was just what they thought a hero ought to be like.

One day Momotaro came to his foster-father and said solemnly:

"Father, by a strange chance we have become father and son. Your goodness to me has been higher than the mountain grasses which it was your daily work to cut, and deeper than the river where my mother washes the clothes. I do not know how to thank you enough."

"Why," answered the old man, "it is a matter of course that a father should bring up his son. When you are older it will be your turn to take care of us, so after all there will be no profit or loss between us – all will be equal. Indeed, I am rather surprised that you should thank me in this way!" and the old man looked bothered.

"I hope you will be patient with me," said Momotaro; "but before I begin to pay back your goodness to me I have a request to make which I hope you will grant me above everything else."

"I will let you do whatever you wish, for you are quite different to all other boys!"

"Then let me go away at once!"

"What do you say? Do you wish to leave your old father and mother and go away from your old home?"

"I will surely come back again, if you let me go now!"

"Where are you going?"

"You must think it strange that I want to go away," said Momotaro, "because I have not yet told you my reason. Far away from here to the northeast of Japan there is an island in the sea. This island is the stronghold of a band of devils. I have often heard how they invade this land, kill and rob the people, and carry off all they can find. They are not only very wicked but they are disloyal to our Emperor and disobey his laws. They are also cannibals, for they kill and eat some of the poor people who are so unfortunate as to fall into their hands. These devils are very hateful beings. I must go and conquer them and bring back all the plunder of which they have robbed this land. It is for this reason that I want to go away for a short time!"

The old man was much surprised at hearing all this from a mere boy of fifteen. He thought it best to let the boy go. He was strong and fearless, and besides all this, the old man knew he was no common child, for he had been sent to them as a gift from Heaven, and he felt quite sure that the devils would be powerless to harm him.

"All you say is very interesting, Momotaro," said the old man. "I will not hinder you in your determination. You may go if you wish. Go to the island as soon as ever you like and destroy the demons and bring peace to the land."

"Thank you, for all your kindness," said Momotaro, who began to get ready to go that very day. He was full of courage and did not know what fear was.

The old man and woman at once set to work to pound rice in the kitchen mortar to make cakes for Momotaro to take with him on his journey. At last the cakes were made and Momotaro was ready to start on his long journey.

Parting is always sad. So it was now. The eyes of the two old people were filled with tears and their voices trembled as they said:

"Go with all care and speed. We expect you back victorious!"

Momotaro was very sorry to leave his old parents (though he knew he was coming back as soon as he could), for he thought of how lonely they would be while he was away. But he said "Good-bye!" quite bravely.

"I am going now. Take good care of yourselves while I am away. Good- bye!" And he stepped quickly out of the house. In silence the eyes of Momotaro and his parents met in farewell.

Momotaro now hurried on his way till it was midday. He began to feel hungry, so he opened his bag and

took out one of the rice-cakes and sat down under a tree by the side of the road to eat it. While he was thus having his lunch a dog almost as large as a colt came running out from the high grass. He made straight for Momotaro, and showing his teeth, said in a fierce way:

"You are a rude man to pass my field without asking permission first. If you leave me all the cakes you have in your bag you may go; otherwise I will bite you till I kill you!"

Momotaro only laughed scornfully:

"What is that you are saying? Do you know who I am? I am Momotaro, and I am on my way to subdue the devils in their island stronghold in the northeast of Japan. If you try to stop me on my way there I will cut you in two from the head downwards!"

The dog's manner at once changed. His tail dropped between his legs, and coming near he bowed so low that his forehead touched the ground.

"What do I hear? The name of Momotaro? Are you indeed Momotaro? I have often heard of your great strength. Not knowing who you were I have behaved in a very stupid way. Will you please pardon my rudeness? Are you indeed on your way to invade the Island of Devils? If you will take such a rude fellow with you as one of your followers, I shall be very grateful to you."

"I think I can take you with me if you wish to go," said Momotaro.

"Thank you!" said the dog. "By the way, I am very very hungry. Will you give me one of the cakes you are carrying?"

"This is the best kind of cake there is in Japan," said Momotaro. "I cannot spare you a whole one; I will give you half of one."

"Thank you very much," said the dog, taking the piece thrown to him.

Then Momotaro got up and the dog followed. For a long time they walked over the hills and through the valleys. As they were going along an animal came down from a tree a little ahead of them. The creature soon came up to Momotaro and said:

"Good morning, Momotaro! You are welcome in this part of the country. Will you allow me to go with you?"

The dog answered jealously:

"Momotaro already has a dog to accompany him. Of what use is a monkey like you in battle? We are on our way to fight the devils! Get away!"

The dog and the monkey began to quarrel and bite, for these two animals always hate each other.

"Now, don't quarrel!" said Momotaro, putting himself between them. "Wait a moment, dog!"

"It is not at all dignified for you to have such a creature as that following you!" said the dog.

"What do you know about it?" asked Momotaro; and pushing aside the dog, he spoke to the monkey:

"Who are you?"

"I am a monkey living in these hills," replied the monkey." I heard of your expedition to the Island of Devils, and I have come to go with you. Nothing will please me more than to follow you!"

"Do you really wish to go to the Island of Devils and fight with me?"

"Yes, sir," replied the monkey.

"I admire your courage," said Momotaro. "Here is a piece of one of my fine rice-cakes. Come along!"

So the monkey joined Momotaro. The dog and the monkey did not get on well together. They were always snapping at each other as they went along, and always wanting to have a fight. This made Momotaro very cross, and at last he sent the dog on ahead with a flag and put the monkey behind with a sword, and he placed himself

between them with a war-fan, which is made of iron.

By and by they came to a large field. Here a bird flew down and alighted on the ground just in front of the little party. It was the most beautiful bird Momotaro had ever seen. On its body were five different robes of feathers and its head was covered with a scarlet cap.

The dog at once ran at the bird and tried to seize and kill it. But the bird struck out its spurs and flew at the dog's tail, and the fight went hard with both.

Momotaro, as he looked on, could not help admiring the bird; it showed so much spirit in the fight. It would certainly make a good fighter.

Momotaro went up to the two combatants, and holding the dog back, said to the bird:

"You rascal! you are hindering my journey. Surrender at once, and I will take you with me. If you don't I will set this dog to bite your head off!"

Then the bird surrendered at once, and begged to be taken into Momotaro's company.

"I do not know what excuse to offer for quarreling with the dog, your servant, but I did not see you. I am a miserable bird called a pheasant. It is very generous of you to pardon my rudeness and to take me with you. Please allow me to follow you behind the dog and the monkey!"

"I congratulate you on surrendering so soon," said Momotaro, smiling. "Come and join us in our raid on the devils."

"Now all of you must listen to me. The first thing necessary in an army is harmony. It is a wise saying which says that 'Advantage on earth is better than advantage in Heaven!' Union amongst ourselves is better than any earthly gain. When we are not at peace amongst ourselves it is no easy thing to subdue an enemy. From now, you three, the dog, the monkey and the pheasant, must be friends with one mind. The one who first begins a quarrel will be discharged on the spot!"

All the three promised not to quarrel. The pheasant was now made a member of Momotaro's suite, and received half a cake. Momotaro's influence was so great that the three became good friends, and hurried onwards with him as their leader.

Hurrying on day after day they at last came out upon the shore of the North-Eastern Sea. There was nothing to be seen as far as the horizon--not a sign of any island. All that broke the stillness was the rolling of the waves upon the shore. Now, the dog and the monkey and the pheasant had come very bravely all the way through the long valleys and over the hills, but they had never seen the sea before, and for the first time since they set out they were bewildered and gazed at each other in silence. How were they to cross the water and get to the Island of Devils?

Momotaro soon saw that they were daunted by the sight of the sea, and to try them he spoke loudly and roughly:

"Why do you hesitate? Are you afraid of the sea? Oh! what cowards you are! It is impossible to take such weak creatures as you with me to fight the demons. It will be far better for me to go alone. I discharge you all at once!"

The three animals were taken aback at this sharp reproof, and clung to Momotaro's sleeve, begging him not to send them away.

"Please, Momotaro!" said the dog.

"We have come thus far!" said the monkey.

"It is inhuman to leave us here!" said the pheasant.

"We are not at all afraid of the sea," said the monkey again.

"Please do take us with you," said the pheasant.

"Do please," said the dog.

They had now gained a little courage, so Momotaro said:

"Well, then, I will take you with me, but be careful!"

Momotaro now got a small ship, and they all got on board. The wind and weather were fair, and the ship went like an arrow over the sea. It was the first time they had ever been on the water, and so at first the dog, the monkey and the pheasant were frightened at the waves and the rolling of the vessel, but by degrees they grew accustomed to the water and were quite happy again. Every day they paced the deck of their little ship, eagerly looking out for the demons' island.

When they grew tired of this, they told each other stories of all their exploits of which they were proud, and then played games together; and Momotaro found much to amuse him in listening to the three animals and watching their antics, and in this way he forgot that the way was long and that he was tired of the voyage and of doing nothing. He longed to be at work killing the monsters who had done so much harm in his country.

As the wind blew in their favor and they met no storms the ship made a quick voyage, and one day when the sun was shining brightly a sight of land rewarded the four watchers at the bow.

Momotaro knew at once that what they saw was the devils' stronghold. On the top of the precipitous shore, looking out to sea, was a large castle. Now that his enterprise was close at hand, he was deep in thought with his head leaning on his hands, wondering how he should begin the attack. His three followers watched him, waiting for orders. At last he called to the pheasant:

"It is a great advantage for us to have you with us." said Momotaro to the bird, "for you have good wings. Fly at once to the castle and engage the demons to fight. We will follow you."

The pheasant at once obeyed. He flew off from the ship beating the air gladly with his wings. The bird soon reached the island and took up his position on the roof in the middle of the castle, calling out loudly:

"All you devils listen to me! The great Japanese general Momotaro has come to fight you and to take your stronghold from you. If you wish to save your lives surrender at once, and in token of your submission you must break off the horns that grow on your forehead. If you do not surrender at once, but make up your mind to fight, we, the pheasant, the dog and the monkey, will kill you all by biting and tearing you to death!"

The horned demons looking up and only seeing a pheasant, laughed and said:

"A wild pheasant, indeed! It is ridiculous to hear such words from a mean thing like you. Wait till you get a blow from one of our iron bars!"

Very angry, indeed, were the devils. They shook their horns and their shocks of red hair fiercely, and rushed to put on tiger skin trousers to make themselves look more terrible. They then brought out great iron bars and ran to where the pheasant perched over their heads, and tried to knock him down. The pheasant flew to one side to escape the blow, and then attacked the head of first one and then another demon. He flew round and round them, beating the air with his wings so fiercely and ceaselessly, that the devils began to wonder whether they had to fight one or many more birds.

In the meantime, Momotaro had brought his ship to land. As they had approached, he saw that the shore was like a precipice, and that the large castle was surrounded by high walls and large iron gates and was strongly fortified.

Momotaro landed, and with the hope of finding some way of entrance, walked up the path towards the top, followed by the monkey and the dog. They soon came upon two beautiful damsels washing clothes in a stream.

Momotaro saw that the clothes were blood-stained, and that as the two maidens washed, the tears were falling fast down their cheeks. He stopped and spoke to them:

"Who are you, and why do you weep?"

"We are captives of the Demon King. We were carried away from our homes to this island, and though we are the daughters of Daimios (Lords), we are obliged to be his servants, and one day he will kill us" – and the maidens held up the blood-stained clothes – "and eat us, and there is no one to help us!"

And their tears burst out afresh at this horrible thought.

"I will rescue you," said Momotaro. "Do not weep any more, only show me how I may get into the castle."

Then the two ladies led the way and showed Momotaro a little back door in the lowest part of the castle wall--so small that Momotaro could hardly crawl in.

The pheasant, who was all this time fighting hard, saw Momotaro and his little band rush in at the back.

Momotaro's onslaught was so furious that the devils could not stand against him. At first their foe had been a single bird, the pheasant, but now that Momotaro and the dog and the monkey had arrived they were bewildered, for the four enemies fought like a hundred, so strong were they. Some of the devils fell off the parapet of the castle and were dashed to pieces on the rocks beneath; others fell into the sea and were drowned; many were beaten to death by the three animals.

The chief of the devils at last was the only one left. He made up his mind to surrender, for he knew that his enemy was stronger than mortal man.

He came up humbly to Momotaro and threw down his iron bar, and kneeling down at the victor's feet he broke off the horns on his head in token of submission, for they were the sign of his strength and power.

"I am afraid of you," he said meekly. "I cannot stand against you. I will give you all the treasure hidden in this castle if you will spare my life!"

Momotaro laughed.

"It is not like you, big devil, to beg for mercy, is it? I cannot spare your wicked life, however much you beg, for you have killed and tortured many people and robbed our country for many years."

Then Momotaro tied the devil chief up and gave him into the monkey's charge. Having done this, he went into all the rooms of the castle and set the prisoners free and gathered together all the treasure he found.

The dog and the pheasant carried home the plunder, and thus Momotaro returned triumphantly to his home, taking with him the devil chief as a captive.

The two poor damsels, daughters of Daimyos, and others whom the wicked demon had carried off to be his slaves, were taken safely to their own homes and delivered to their parents.

The whole country made a hero of Momotaro on his triumphant return, and rejoiced that the country was now freed from the robber devils who had been a terror of the land for a long time.

The old couple's joy was greater than ever, and the treasure Momotaro had brought home with him enabled them to live in peace and plenty to the end of their days.

ILLUSTRATIONS
Page 60: Momotaro with his animal companions; art by Kuniyoshi (1840).
Page 61: Momotaro wrestling with Kintaro; art by Kunisada (1843).
Page 66: Momotaro in the demons' lair; art by Kuniyoshi, from the series **100 Tales Of Military Valour** (1836).
Page 68: Momotaro holds the Demon King captive; art by Kuniyoshi, from the series **Japanese And Chinese Comparisons For The Chapters Of The Genji** (1855).

THE NIGHT PARADE OF 100 GHOSTS

Some four or five hundred years ago there was an old temple not far from Fushimi, near Kyoto. It was called the Shozenji temple, and had been deserted for many years, priests fearing to live there, on account of the ghosts which were said to haunt it. Still, no one had ever seen the ghosts. No doubt the story came into the people's minds from the fact that all of the priests had been killed by a large band of robbers many years beyond the memory of men – for the sake of loot, of course. So great a horror did this strike into the minds of all, that the temple was allowed to rot and run to ruin.

One year a wandering priest passed by the temple, and, not knowing its history, went in and sought refuge from the weather, instead of continuing his journey to Fushimi. Having cold rice in his wallet, he felt that he could not do better than pass the night there; for, though the weather might be cold, he would at all events save drenching the only clothes which he had, and be well off in the morning. The good man took up his quarters in one of the smaller rooms, which was in less bad repair than the rest of the place; and, after eating his meal, said his prayers and lay down to sleep, while the rain fell in torrents on the roof and the wind howled through the creaky buildings. Try as he might, the priest could not sleep, for the cold draughts chilled him to the marrow.

Somewhere about midnight the old man heard weird and unnatural noises. They seemed to proceed from the main building. Prompted by curiosity, he arose; and when he got to the main building he saw *Hiyakki Yakô* (meaning a procession of one hundred ghosts). The ghosts fought, wrestled, danced, and made merry. Though greatly alarmed at first, the priest became intrigued. After a few moments, however, more awful spirit-like ghosts came on the scene. The priest ran back to the small room, into which he barred himself; and he spent the rest of the night saying masses for the souls of the dead.

At daybreak, the priest departed. He told the villagers what he had seen, and they spread the news so widely that within three or four days the temple was known as the worst-haunted temple in the land. It was at this time that the celebrated painter Tosa Mitsunobu heard of it. Having ever been anxious to paint a picture of *Hiyakki Yakô*, he thought that a sight of the ghosts in Shozenji temple might give him the necessary material: so off to Fushimi and Shozenji he started. Mitsunobu went straight to the temple at dusk, and sat up all night in a nervous state of mind; but he saw no ghosts, and heard no noise.

Next morning he opened all the windows and doors and flooded the main temple with light. No sooner had he done this than he found the walls of the place covered, as it were, with the figures or drawings of ghosts of indescribable complexity. There were far more than two hundred, and all different. Drawing his notebook and brush from his pocket, he proceeded to copy them down minutely. This occupied the best part of the day.

During his examination of the outlines of the various ghosts and goblins which he had drawn, Mitsunobu saw that the fantastic shapes had come from cracks in the damp deserted walls; these cracks were filled with fungi and mildew, which in their turn produced the toning, colouring, and eventually the figures of the one hundred ghosts. Grateful was he to the priest whose stories had led him to the place, for without him the picture could never have been drawn; never could the horrible aspects of so many ghosts and goblins have entered the mind of one man.

ILLUSTRATION
Page 70: **The Night Parade Of 100 Ghosts**; art by Kawanabe Kyosai (c.1880)

THE STORY OF YOSHITSUNE

In old Japan more than seven hundred years ago a fierce war was raging between the two great clans, the Taira and the Minamoto, also called the Heike and the Genji. These two famous clans were always contesting together for political power and military supremacy, and the country was torn in two with the many bitter battles that were fought. Indeed it may be said that the history of Japan for many years was the history of these two mighty martial families; sometimes the Minamoto and sometimes the Taira gaining the victory, or being beaten, as the case might be; but their swords knew no rest for a period of many years. At last a strong and valiant general arose in the House of Minamoto. His name was Yoshitomo. At this time there were two aspirants for the Imperial throne and civil war was raging in the capital. One Imperial candidate was supported by the Taira, the other by the Minamoto. Yoshitomo, though a Minamoto, sided at first with the Taira against the reigning Emperor; but when he saw how cruel and relentless their chief, Kiyomori, was, he turned against him and called all his followers to rally round the Minamoto standard and fight to put down the Taira.

But fate was against the gallant and doughty warrior Yoshitomo, and he suffered a crushing defeat at the hands of the Taira. He and his men, while fleeing from the vigilance of their enemies, were overtaken within the city gates, and ruthlessly slaughtered by Kiyomori and his soldiers.

Yoshitomo left behind him his beautiful young wife, Tokiwa Gozen, and eight children, to mourn his untimely death. Five of the elder children were by a first wife. The third of these became Yoritomo, the great first Shogun of Japan, while the eighth and youngest child was Ushiwaka, about whom this story is written. Ushiwaka and the here Yoshitsune were one and the same person. Ushiwaka (Young Ox-he was so called because of his wonderful strength) was his name as a boy, and Yoshitsune was the name he took when he became of age.

At the time of his father's death, Ushiwaka was a babe in the arms of his mother, Tokiwa Gozen but his tender age would not have saved his life had he been found by his father's enemies.

After the defeat they had inflicted on the rival clan, the Taira were all-powerful for a time. The Minamoto clan

were in dire straits and in danger of being exterminated now, for so fierce was Kiyomori's hatred against his enemies that when a Minamoto fell into his cruel hands he immediately put the captive to death.

Realizing the great peril of the situation, Tokiwa Gozen, the widow of Yoshitomo, full of fear and anxiety for the safety of her little ones, quietly hid herself in the country, taking with her Ushiwaka and her two other children. So successful was Tokiwa Gozen in concealing her hiding-place that, though the Taira clan either killed or banished to a far-away island all the elder sons, relations, and partisans of the Minamoto chief, they could not discover the whereabouts of the mother and her children, notwithstanding the strict search Kiyomori had made.

Determined to have his will, and angry at being thwarted by a woman, Kiyomori at last hit on a plan which he felt sure would not fail to draw the wife of Yoshitomo from her hiding-place. He gave orders that Sekiya, the mother of the fair Tokiwa, should be seized and brought before him. He told her sternly that if she would reveal her daughter's hiding-place she should be well treated, but if she refused to do as she was told she would be tortured and put to death. When the old lady declared that she did not know where Tokiwa was, as in truth she did not, Kiyomori thrust her into prison and had her treated cruelly day after day.

Now the reason why Kiyomori was so set on finding Tokiwa and her sons was that while Yoshitomo's heirs lived he and his family could know no safety, for the strongest moral law in every Japanese heart was the old command, "A man may not live under the same heaven with the murderer of his father," and the Japanese warrior recked nothing of life or death, of home or love in obeying this – as he deemed – supreme commandment. Women too burned with the same zeal in avenging the wrongs of their fathers and husbands.

Tokiwa Gozen, though hiding in the country, heard of what had befallen her mother, and great was her sorrow and distress. She sat down on the mats and moaned aloud: "It is wrong of me to let my poor innocent mother suffer to save myself and my children, but if I give myself up, Kiyomori will surely take my lord's sons and kill them. What shall I do? Oh! what shall I do?"

Poor Tokiwa! Her heart was torn between her love for her mother and her love for her children. Her anxiety and distraction were pitiful to see. Finally she decided that it was impossible for her to remain still and silent under the circumstances; she could not endure the thought that her mother was suffering persecution while she had the power of preventing it, so holding the infant Ushiwaka in her bosom under her kimono, she took his two elder brothers (one seven and the other five years of age) by the hand and started for the capital.

There were no trains in those days and all travelling by ordinary people had to be done on foot. Daimios and great and important personages were carried in palanquins, and they only could travel in comfort and in state. Tokiwa could not hope to meet with kindness or hospitality on the way, for she was a Minamoto, and the Taira being all-powerful it was death to any one to harbour a Minamoto fugitive. So the obstacles that beset Tokiwa were great; but she was a samurai woman, and she quailed not at duty, however hard or stern that duty was. The greater the difficulties, the higher her courage rose to meet them. At last she set out on her momentous and celebrated journey.

It was winter-time and snow lay on the ground, and the wind blew piercingly cold and the roads were bad. What Tokiwa, a delicately nurtured woman, suffered from cold and fatigue, from loneliness and fear, from anxiety for her little children, from dread lest she should reach the capital too late to save her old mother, who might die under the cruel treatment to which she was being subjected, or be put to death by Kiyomori, in his wrath, or finally lest she herself should be seized by the Taira, and her filial plan be frustrated before she could reach the capital – all this must have been greater than any words can tell.

Sometimes poor distressed Tokiwa sat down by the wayside to hush the wailing babe she carried in her bosom, or to rest the two little boys, who, tired and faint and famished, clung to her robes, crying for their usual rice.

On and on she went, soothing and consoling them as best she could, till at last she reached Kyoto, weary, footsore, and almost heart-broken. But though she was well-nigh overcome with physical exhaustion, yet her purpose never flagged. She went at once to the enemy's camp and asked to be admitted to the presence of General Kiyomori.

When she was shown into the dread man's presence, she prostrated herself at his feet and said that she had come to give herself up and to release her mother.

"I am Tokiwa – the widow of Yoshitomo. I have come with my three children to beseech you to spare my mother's life and to set her free. My poor old mother has done nothing wrong. I am guilty of hiding myself and the little ones, yet I pray humbly for your august forgiveness."

She pleaded in such an agonizing way that Kiyomori, the Taira chieftain, was struck with admiration for her filial piety, a virtue more highly esteemed than any other in Japan. He felt sincerely sorry for Tokiwa in her woe, and her beauty and her tears melted his hard heart, and he promised her that if she would become his wife he would spare not only her mother's life, but her three children also.

For the sake of saving her children's lives the sad-hearted woman consented to Kiyomori's proposal. It must have been terrible to her to wed with her lord's enemy, the very man who had caused his death; but the thought that by so doing she saved the lives of his sons, who would one day surely arise to avenge their father's cruel death, must have been her consolation and her recompense for the sacrifice.

Kiyomori showed himself kinder to Tokiwa than he had ever shown himself to any one, for he allowed her to keep the babe Ushiwaka by her side. The two elder boys he sent to a temple to be trained as acolytes under the tutelage of priests.

By placing them out of the world in the seclusion of priesthood, Kiyomori felt that he would have little to fear from them when they attained manhood. How terribly and bitterly he was mistaken we learn from history, for two of Yoshitomo's sons, banished though they had been for years and years, arose like a rushing, mighty whirlwind from the obscurity of the monastery to avenge their father, and they wiped the Taira from off the face of the earth.

Time passed by, and when the little babe Ushiwaka at last reached the age of seven, Kiyomori likewise took him from his mother and sent him to the priests. The sorrow of Tokiwa, bereft of the last child of her beloved lord Yoshitomo, can better be imagined than described. But in her golden captivity even Kiyomori had not been able to deprive her of one iota of the incomparable power of motherhood, that of influencing the life of her child to the end of his days. As the little fellow had lain in her arms night and day, as she crooned him to sleep and taught him to walk, she forever whispered the name of Minamoto Yoshitomo in his ear.

At last one day her patience was rewarded and Ushiwaka lisped his father's name correctly. Then Tokiwa clasped him proudly to her breast, and wept tears of thankfulness and joy and of sorrowing remembrance, for she could never even for a day banish Yoshitomo from her mind. As Ushiwaka grew older and could understand better what she said, Tokiwa would daily whisper, "Remember thy father, Minamoto Yoshitomo! Grow strong and avenge his death, for he died at the hands of the Taira!" And day by day she told him stories of his great and good father-of his martial prowess in battle, and of his great strength and wonderful wielding of the sword, and she bade her little son remember and be like his father. And the mother's words and tears, sown in long years of patience and bitter endurance, bore fruit beyond all she had ever hoped or dreamed.

So Ushiwaka was taken from his mother at the age of seven, and was sent to the Tokobo Monastery, at Kuramayama, to be trained as a monk.

Even at that early age he showed great intelligence, read the Sacred Books with avidity, and surprised the priests by his diligence and quickness of memory. He was naturally a very high-spirited youth, and could brook no

control and hated to yield to others in anything whatsoever. As the years passed by and he grew older, he came to hear from his teachers and school friends of how his father Yoshitomo and his clan the Minamoto had been overthrown by the Taira, and this filled him with such intense sorrow and bitterness that sleeping or waking he could never banish the subject from his mind. As he listened daily to these things the words of his mother, which she had whispered in his ear as a child, now came throbbing back to his mind, and he understood their full meaning for the first time. In the lonely nights he felt again her hot tears falling on his face, and heard her repeat as clearly as a bell in the silence of the darkness: "Remember thy father, Minamoto Yoshitomo! Avenge his death, for he died at the hands of the Taira!"

At last one night the lad dreamed that his mother, beautiful and sad as he remembered her in the days of his childhood, came to his bedside and said to him, while the tears streamed down her face: "Avenge thy father, Yoshitomo! Unless thou remember my last words, I cannot rest in my grave. I am dying, Ushiwaka, remember!"

And Ushiwaka awoke as he cried aloud in his agony: "I will! Honourable mother, I will!"

From that night his heart burned within him and the fire and love of clan-race stirred his soul. Continual brooding over the wrongs of his clan generated in his heart a fierce desire for revenge, and he finally resolved to abandon the priesthood, become a great general like his father, and punish the Taira. And as his ambition was fired and exalted and his mind thrilled back to the days when his poor unhappy mother Tokiwa prayed and wept over him, daily whispering in his ear the name of his father, his will grew to purpose strong. Tokiwa had not suffered in vain. From this time on, Ushiwaka bided his time every night till all in the temple were fast asleep. When he heard the priests snoring, and knew himself safe from observation, he would steal out from the temple, and, making his way down the hillside into the valley, he would draw his wooden sword and practice fencing by himself, and, striking the trees and the stones imagine that they were his Taira foes. As he worked in this way night after night, he felt his muscles grow strong, and this practice taught him how to wield his sword with skill.

One night as usual Ushiwaka had gone out to the valley and was diligently brandishing about his wooden sword. His mind fully bent upon his self-taught lesson, he was marching up and down, chanting snatches of war-songs and striking the trees and the rocks, when suddenly a great cloud spread over the heavens, the rain fell, the thunder roared, and the lightning flashed, and a great noise went through the valley, as if all the trees were being torn up by the roots and their trunks were splitting.

While Ushiwaka wondered what this could mean, a great giant over ten feet in height stood before him. He had large round glaring eyes that glinted like metal mirrors; his nose was bright red, and it must have been about a foot long; his hands were like the claws of a bird, and to each there were only two fingers. The feathers of long wings at each side peeped from under the creature's robes, and he looked like a gigantic goblin. Fearful indeed was this apparition. But Ushiwaka was a brave and spirited youth and the son of a soldier, and he was not to be daunted by anything. Without moving a muscle of his face he gripped his sword more tightly and simply asked: "Who are you, sir?"

The goblin laughed aloud and said: "I am Sojobo, the King of the Tengu, the elves of the mountains, and I have made this valley my home for many a long year. I have admired your perseverance in coming to this place night after night for the purpose of practicing fencing all by yourself, and I have come to meet you, with the intention of teaching you all I know of the art of the sword."

Ushiwaka was delighted when he heard this, for the Tengu have supernatural powers, and fortunate indeed are those whom they favour. He thanked the giant elf and expressed his readiness to begin at once. He then whirled up his sword and began to attack the Tengu, but the elf shifted his position with the quickness of lightning, and taking from his belt a fan made of seven feathers parried the showering blows right and left so cleverly that the young knight's interest became thoroughly aroused. Every night he came out for the lesson. He never missed once, summer or winter, and in this way he learned all the secrets of the art which the Tengu could teach him.

The Tengu was a great master and Ushiwaka an apt pupil. He became so proficient in fencing that he could overcome ten or twenty small Tengu in the twinkling of an eye, and he acquired extraordinary skill and dexterity in the use of the sword; and the Tengu also imparted to him the wonderful adroitness and agility which made him so famous in after-life.

Now Ushiwaka was about fifteen years old, a handsome youth, and tall for his age. At this time there lived on Mount Hiei, just outside the capital, a wild bonze named Musashi Bo Benkei, who was such a lawless and turbulent fellow that he had become notorious for his deeds of violence. The city rang with the stories of his misdeeds, and so well known had he become that people could riot hear his name without fear and trembling.

Benkei – who in his youth had been named Oniwaka, or Demon Child – suddenly made up his mind that it would be good sport to steal a thousand swords from various knights.

No sooner did the wild idea enter his head than he began to put it into practice. Every night he sauntered forth to the Gojo Bridge of Kyoto, and when a knight or any man carrying a sword passed by, Benkei would snatch the weapon from his girdle. If the owners yielded up their blades quietly, Benkei allowed them to pass unhurt, but if not, he would strike them dead with a single blow of the huge halberd he carried. So great was Benkei's strength that he always overcame his victim – resistance was useless – and night by night one or sometimes two men met death at his hands on the Gojo Bridge. In this way Benkei gained such a terrible reputation that everybody far and near feared to meet him, and after dark no one dared to pass near the bridge he was known to haunt, so fearful were the tales told of the dreaded robber of swords.

At last this story reached the ears of Ushiwaka, and he said to himself: "What an interesting man this must be! If it is true that he is a bonze, he must be a strange one indeed; but as he only robs people of their swords, he cannot be a common highwayman. If could make such a strong man a retainer of mine, he would be a great assistance to me when I punish my enemies, the Taira clan. Good! Tonight I will go to the Gojo Bridge and try the mettle of this Benkei!"

Ushiwaka, being a youth of great courage, had no sooner made up his mind to meet Benkei than he proceeded to put his plan into execution. He started out that same evening. It was a beautiful moonlight night, and taking with him his favourite flute he strolled forth through the streets of the sleeping city till he came to the Gojo Bridge. Then from the opposite direction came a tall figure which appeared to touch the clouds, so gigantic was its stature. The stranger was clad in a suit of coal-black armour and carried an immense halberd.

"This must be the sword-robber! He is indeed strong!" said Ushiwaka to himself, but he was not in the least daunted, and went on playing his flute quite calmly. Presently the armed giant halted and gazed at Ushiwaka, but evidently thought him a mere youth, and decided to let him go unmolested, for he was about to pass him by without lifting a hand. This indifference on the part of Benkei not only disappointed but angered Ushiwaka. Having waited in vain for the stranger to offer violence, our hero approached Benkei, and, with the intention of picking a quarrel, suddenly kicked the latter's halberd out of his hand.

Benkei, who had first thought to spare Ushiwaka on account of his youth, became very angry when he found himself insulted by a lad to whom he had been intentionally kind. In a fury he exclaimed, "Miserable stripling!" and raising his halberd struck sideways at Ushiwaka, thinking to slice him in two at the waist and to see his body fall asunder. But the young knight nimbly avoided the blow which would have killed him, and springing back a few paces he flung his fan at Benkei's head and uttered a loud cry of defiance. The fan struck Benkei on the forehead right between the eyes, making him mad with pain. In a transport of rage Benkei aimed a fearful blow at Ushiwaka, as if he were splitting a log of wood with an axe. This time Ushiwaka sprang up to the parapet of the bridge, clapped his hands, and laughed in derision, saying:

"Here I am! Don't you see? Here I am!" and Benkei was again thwarted thus.

Benkei, who had never known his strokes miss before, had now failed twice in catching this nimble opponent. Frantic with chagrin and baffled rage, he now rushed furiously to the attack, whirling his great halberd round in all

directions till it looked like a water-wheel in motion, striking wildly and blindly at Ushiwaka. But the young knight had been taught tricks innumerable by the giant Tengu of Kuramayama, and he had profited so well by his lessons that the King Tengu had at last said that even he could teach him nothing more, and now, as it may well be imagined, he was too quick for the heavy Benkei. When Benkei struck in front, Ushiwaka was behind, and when Benkei aimed a blow behind, Ushiwaka darted in front. Nimble as a monkey and swift as a swallow, Ushiwaka avoided all the blows aimed at him, and, finding himself outmatched, even the redoubtable Benkei grew tired.

Ushiwaka saw that Benkei was played out. He kept up the game a little longer and then changed his tactics. Seizing his opportunity, he knocked Benkei's halberd out of his hand. When the giant stooped to pick his weapon up, Ushiwaka ran behind him and with a quick movement tripped him up. There lay the big man on all fours, while Ushiwaka nimbly strode across his back and pressing him down asked him how he liked this kind of play.

All this time Benkei had wondered at the courage of the youth in attacking and challenging a man so much larger than himself, but now he was filled with amazement at Ushiwaka's wonderful strength and adroitness.

"I am indeed astonished at what you have done," said Benkei. "Who in the world can you be? I have fought with many men on this bridge, but you are the first of my antagonists who has displayed such strength. Are you a god or a tengu? You certainly cannot be an ordinary human being!"

Ushiwaka laughed and said: "Are you afraid for the first time, then?"

"I am," answered Benkei.

"Will you from henceforth be my retainer?" demanded Ushiwaka.

"I will in very truth be your retainer, but may I know who you are?" asked Benkei meekly.

Ushiwaka now felt sure that Benkei was in earnest. He therefore allowed him to get up from the ground, and then said: "I have nothing to hide from you. I am the youngest son of Minamoto Yoshitomo and my name is Ushiwaka."

Benkei started with surprise when he heard these words and said: "What is this I hear? Are you in truth a son of the Lord Yoshitomo of the Minamoto clan? That is the reason I felt from the first moment of our encounter that your deeds were not those of a common person. No wonder that I thought this! I am only too happy to become the retainer of such a distinguished and spirited young knight. I will follow you as my lord and master from this very moment, if you will allow me. I can wish for no greater honour."

So there and then, on the Gojo Bridge in the silver moonlight, the bonze Benkei vowed to be the true and faithful vassal of the young knight Ushiwaka and to serve him loyally till death, and thus was the compact between lord and vassal made. From that time on, Benkei gave up his wild and lawless ways and devoted his life to the service of Ushiwaka, who was highly pleased at having won such a strong liegeman to his side.

Although Ushiwaka had now secured Benkei, it was impossible for only two men, however strong, to think of fighting the Taira clan, so they both decided that the cherished plan must wait till the Minamoto were stronger. While thus waiting they heard a report to the effect that a descendant of Tawara Toda Hidesato named Hidehira was now a famous general in Kaiwai of the Ashu Province, and that he was so powerful that no one dared oppose him. Hearing this, Ushiwaka thought that it would be a good plan to pay the general a visit and try to interest him, if possible, in the fortunes of the House of Minamoto. He consulted with Benkei, who encouraged the young knight in his scheme of enlisting the General Hidehira as a partisan, and the two therefore left Kyoto secretly and journeyed as quickly as possible to Oshu on this errand.

On the way there, Ushiwaka and Benkei came to the Temple of Atsuta, and as they considered it important that the young knight should look older now, Ushiwaka performed the ceremony of Gembitku at the shrine. This was a rite performed in olden times when youths reached the age of manhood. They then had to shave off the front part

of their hair and to change their names as a sign that they had left childhood behind. Ushiwaka now took the name of Yoshitsune. As he was the eighth son, it would have been more correct for him to have assumed the name of Hachiro, but as his uncle Tametomo the Archer was named Hachiro, he purposely did not take this name. From this time forth our hero is known as Yoshitsune, and this name he has glorified forever by his wonderful bravery and many heroic exploits. In Japanese history he is the knight without fear and without reproach, the darling of the people, to them almost an incarnation of Hachiman, the popular God of War. And as for Benkei, never can you find in all history a vassal who was more true or loyal to his master than Benkei. He was Yoshitsune's right hand in everything, and his strength and wisdom carried them successfully through many a dire emergency.

From Kyoto to Oshu is a long journey of about three hundred miles, but at length Yoshitsune (as we must now call him) and Benkei reached their destination and craved the General Hidehira's assistance. They found that Hidehira was a warm adherent of the Minamoto cause, and under the late Lord Yoshitomo he and his family had enjoyed great favour. When the general learned, therefore, that Yoshitsune was the son of the illustrious Minamoto chief, his joy knew no bounds, and he made Yoshitsune and Benkei heartily welcome and treated them both as guests of honour and importance.

Just at this time Yoshitsune's eldest brother, Yoritomo, who had been banished to an island in Idzu, collected a great army and raised his standard against the Taira. When the news about Yoritomo reached Yoshitsune, he rejoiced, for he felt that the hour had at last come when the Minamoto would be revenged on the Taira for all the wrongs they had suffered at the hands of the latter.

With the help of Hidehira and the faithful Benkei, he collected a small army of warriors and at once marched over to his brother's camp in Idzu. He sent a messenger ahead to inform Yoritomo that his youngest brother, now named Yoshitsune, was coming to aid him in his fight against the Taira.

Yoritomo was exceedingly glad at this unexpected good news, for all that helped to swell his forces now brought nearer the day when he would be able to strike his long-planned blow at the power of the hated Taira. As soon as Yoshitsune reached Idzu, Yoritomo arranged for an immediate meeting. Although the two men were brothers, it must be remembered that their father had been killed, and the family utterly scattered, when they were mere children, Yoshitsune being at that time but an infant in his mother's arms. As this was therefore the first time they had met Yoritomo knew nothing of his young brother's character.

One of Yoshitsune's elder brothers had come with him, and Yoritomo being a shrewd general wished to test them both to see of what mettle they were made. He ordered his retainers to bring a brass basin full of boiling water. When it was brought, Yoritomo ordered Noriyori, the elder of the two, to carry it to him first. Now brass being a good conductor of heat, the basin was very hot and Noriyori stupidly let it fall. Yoritomo ordered it to be filled again and bade Yoshitsune bring it to him. Without moving a muscle of his handsome face Yoshitsune took hold of the almost unbearably hot vessel and carried it with due ceremony slowly across the room. This exhibition of nerve and endurance filled Yoritomo with admiration and he was favourably struck with Yoshitsune's character. As for Noriyori, who had been unable to hold a hot basin for a few moments, he had no use for him at all, except as a common soldier.

Yoritomo begged Yoshitsune to become his right-hand man and zealously to espouse his cause. Yoshitsune declared that this had been his lifelong ambition ever since he could remember,-as they both were sons of the same father, so was their cause and destiny one. Yoritomo made Yoshitsune a general of part of his army and ordered him in the name of his father Yoshitomo to chastise the Taira.

Delighted beyond all words at the wonderfully auspicious turn events were taking, Yoshitsune hastened his preparations for the march. The longed-for hour had come to which through his whole childhood and youth he had

looked forward, and for which his whole being had thirsted for many years. He could now fulfil the last words of his unhappy mother, and punish the Taira for all the evil they had wrought against the Minamoto. All the wild restlessness of his youth, which had driven him forth to wield his wooden sword against the rocks in the Kuramayama Valley and to try his strength against Benkei on the Gojo Bridge, now found vent in action most dear to a born warrior's heart. With several thousands of troops under him, Yoshitsune marched up to Kyoto and waged war against the Taira, and defeated them in a series of brilliant engagements.

The stricken Taira multitudes fled before the avenger like autumn leaves before the blast, and Yoshitsune pursued them to the sea. At Dan-no-Ura the Taira made a last stand, but all in vain. Their lion leader, Kiyomori, was dead, and there was no great chieftain to rally them in the disordered retreat that now ensued. Yoshitsune came sweeping down upon them, and they and their fleet and their infant Emperor likewise, with their women and children, sank beneath the waves. Only a scattered few lived to tell the tale of the terrible destruction that overtook them on the sea.

Thus did Yoshitsune become a great warrior and general. Thus did he fulfil the ambitions of his youth and avenge his father Yoshitomo's death. He was without a rival in the whole country for his marvellous bravery and successive victories. He was adored by the people as their most popular hero and darling, and throughout the length and breadth of the land his praise was sung by every one.

Now Yoritomo, when he saw his brother's popularity, became jealous, and Kajiwara, one of his generals, who hated Yoshitsune because the young knight had once openly reproved him for cowardice, seized the opportunity to poison Yoritomo's mind against his younger brother; he suggested that Yoshitsune's aim was to supplant Yoritomo in supreme authority. Sad to say, Yoritomo believed this wicked slander. Therefore, when Yoshitsune, covered with glory and honour, returned from the wars, bringing with him, as prisoners of war, Munemori, the Taira chieftain, and his son (Kiyo-mori was now dead), he found that Yoritomo had erected a barrier near Koshigoe, just outside Kamakura. Here he sent a guard to receive the prisoners, but on the ground that Yoshitsune was guilty of treachery, Yoritomo refused him admittance into Kamakura. In vain did Yoshitsune protest against the unjust accusation; in vain did he write a touching letter avowing his unaltered love and devotion to Yoritomo; in vain did he recount all the hardships

endured on the campaigns which the young and chivalrous general had undertaken at the command of his brother. He was not believed, and ingratitude was the only reward he received for devotion to his brother's cause. At this crisis Yoshitsune found himself banished and every part of Japan rendered unsafe for his residence, for Yoritomo ordered him to be arrested. When this time of trouble came, Benkei was indefatigable in his efforts to guard Yoshitsune's person from danger. He followed him in his flight and exile and never left his master's side.

Yoshitsune now returned to Kyoto for a time. Soon after he arrived there Yoritomo sent a man named Tosabo to compass his death. This man, like Benkei, had formerly been a bonze, and he gave out that he had come to visit the temples of the capital.

Tosabo knew very well what a shrewd and clever warrior Yoshitsune was, and he doubted his own ability to cope with the task he had undertaken. He therefore decided that he would wait until Yoshitsune was completely off his guard, and then make a sudden attack upon the house where he was staying. He told his followers of his plan and secretly prepared for the raid. Yoshitsune soon learned of Tosabo's coming, for the people of Kyoto and its neighbourhood, where he had lived as a boy, were devoted to him. The young general, knowing that Tosabo was in Yoritomo's service, regarded him with suspicion. He told Benkei of his fears, and Benkei at once volunteered to go and summon Tosabo to the house and question him.

Yoshitsune agreed to the plan, and Benkei immediately set off for Tosabo's house. "Now, Tosabo," said he, "my Lord Yoshitsune desires to see you, so you are to come back with me at once!"

Benkei's manner was so fierce and determined that Tosabo felt alarmed and he therefore pretended to be ill; but Benkei was not to be balked that stupid way, and shouting: "If you are not quick, I'll seize you and take you whether you will or not!" he grabbed Tosabo by his girdle and lifted him up as if he had been a child, tucked him under one arm, and, mounting his horse, carried him off.

There were several of Tosabo's retainers present at the interview, but they were all trembling with fear and did not dare to put forth a hand to help their master.

Benkei thus conducted Tosabo into the presence of Yoshitsune by force, and both master and vassal began to examine him strictly; but Tosabo was such an audacious rascal that, notwithstanding the fact that he had actually come from Yoritomo, hired as an assassin, he refused to confess anything. With great humility he feigned surprise at being suspected of entertaining designs against Yoshitsune's life, saying that he was but a poor bonze in Yoritomo's service, and as Yoshitsune was his master's brother, he (Tosabo) regarded him as his lord also. Nothing else but a religious fast and retreat had called him to Kyoto!

Now Yoshitsune and Benkei had no actual proof of his guilt, so they allowed Tosabo to go free, first making him sign a document declaring that he was not a hired assassin. In truth neither of them believed the crafty man, but thought him too despicable an enemy to fear, and made up their minds that, if he and his gang planned a night assault, the party could be easily repulsed and put to night. Tosabo on his part congratulated himself on his cleverness, returned home, armed his men, and made an attack on Yoshitsune's residence.

Yoshitsune that night, thinking that at any rate for some time he was quite safe from attack, made merry with all his men. Drinking amber-coloured wine they sat up late, and when at last the young general retired to rest, having drunk much he slept a deep sleep. His beautiful young wife Shizuka, who accompanied him in all his wanderings, fearing she knew not what, that night alone kept watch beside her lord's couch. She was the first to hear the approach of Tosabo and his soldiers. Vainly she tried to rouse Yoshitsune; she called him, she shook him, but all in vain – he slept on. Shizuka was frantic. She heard the enemy at the gate trying to batter it down. Suddenly the thought struck her, as if by inspiration, that the most thrilling call to arms to a warrior must be the sound of his armour. She rushed

to the box in the hall, and heavy as it was for her slender strength, she lifted out the armour. She dragged it quickly into the room. Then over Yoshitsune's head she waved it to and fro. "Clang-clang," sounded the armour, "clang-clang." Up sprang the warrior, seized the suit of armour, and with Shizuka's help dressed himself for battle. All this took place without a single word. Benkei and the rest of his soldiers soon joined him and the enemy were put to flight. Tosabo managed to escape and hide himself in the mountains of Kurama, near Kyoto, but he was caught and put to death at last.

To have been able to thwart and punish the assassins from Kamakura was a source of great satisfaction to Yoshitsune and his men; but when the story reached Yoritomo he was very wroth, and issued another decree entirely disowning Yoshitsune and declaring him an enemy to the state.

Yoshitsune felt that Yoritomo was acting most unjustly towards him, for he knew himself to be entirely blameless of plotting against Yoritomo's supremacy; but as it was useless to contend against his elder brother, who as Shogun was the military ruler of Japan, he decided to leave Kyoto and escape to some other place. He therefore planned to cross from the province of Settsu to Saikoku in a ship; but when they reached Dan-no-Ura, where Yoshitsune had finally conquered and all but exterminated the Taira clan, the fine weather they had hitherto experienced suddenly changed, the sky became overcast with black clouds, rain began to fall in torrents, the wind began to blow, and gradually the waves rose higher and higher, and shipwreck became imminent. As the darkness deepened about them, though they could see nothing, over the water there came weird sounds of the din of battle, the rushing of ships through the sea, the shouting and trampling of men, the whizzing of arrows in the air; all around them as the ship sped on, the tumult of the fight grew louder, till Yoshitsune felt that he was living again through that awful and never-to-be-forgotten battle.

Then from amid the rolling waves, which every moment threatened to engulf the boat, arose pale, ghastly forms whose wan faces were terrible to see. Clad in blood-stained, battle-torn armour and ravaged with gaping wounds, these warrior ghosts raised threatening hands, as if to stop the progress of the boat, while moanings of despair and hollow sobs and shrieks burst from the spectre army. Among the foremost figures was one who brandished a huge halberd, and as he approached, he addressed Yoshitsune, saying: "Aha! Revenge! Revenge! Behold in me the ghost of Taira-no-Tomomori, general of the Taira clan, ruthlessly destroyed by you! Long have I waited here for you and now I will slay you all, for not until then will the slaughtered Taira rest in their watery graves."

Through the tossing, whirling waters, with the wind shrieking round them, and a weird blue phosphoric light making everything visible, the phantom host drew nearer and nearer to the boat. But Yoshitsune did not seem to be in the least alarmed. As dauntless as ever, he stood up in the prow and faced the ghosts of the men whom he had slain in that terrible battle, and flashing forth his keen blade, said: "So you are the spirits of the Taira clan, are you? And you have risen from the ocean-bed to haunt us, and to impede our progress, and to inflict evil upon us? Have you forgotten how I drove you before me as dust before the wind when you were alive? It is a pity you have not profited by past experiences! I should have thought that you would have had no wish to see me again!"

With these words he was about to brandish his sword and attack the spectres, but Benkei, the wise and faithful Benkei, stepped up to his young master and stayed his hand, saying: "Not so, my lord. Swords are useless against ghosts. It is not wise to anger these poor earth-bound phantoms. The best way of dealing with them is to pacify them, so that they may find peace and go to their own place."

Yoshitsune yielded to Benkei and allowed himself to be put aside. Then Benkei, who, you will remember, had formerly been a Buddhist priest, drew out a small rosary which he always carried with him, and telling his beads, and rubbing his hands together, palm to palm, began to recite prayers earnestly and reverently in a loud voice. The

sacred words appointed by the Buddhist Church fell like a benediction upon the angry spirits, the wailing and the howling and the tumult of the phantom conflict ceased, and the wraiths gradually vanished into the sea from whence they had arisen; the storm ceased, and the weather cleared and became as fine and peaceful as it was before, and the travellers soon reached the land in safety.

ILLUSTRATIONS
Page 72: Ushiwaka-maru learning martial skills from the tengu king, from the series **Life Of Yoshitsune**; art by Kuniyoshi (1853).
Page 73: Benkei and Yoshitsune behold a white dragon rising at the Battle of Takadachi in 1187; art by Kuniyoshi (1857).
Page 76: Ushiwaka-maru learning martial skills from the tengu; art by Yoshikazu (c.1858).
Page 77: Ushiwaka-maru learning martial skills from the tengu; art by Kunitsuna (1859).
Page 78: Yoshitsune, assisted by the tengu, thwarting Benkei on Gojo bridge; art by Kuniyoshi (c.1850).
Page 79: Yoshitsune thwarting Benkei on Gojo bridge; art by Yoshifuji (c.1845).
Page 82: The great sea battle at Dan-no-Ura; art by Yoshitora (1862).
Page 84: Yoshitsune and Shizuka Gozen defending the Horikawa mansion against Tosabo Shoshun, from the series **Life Of Yoshitsune**; art by Kuniyoshi (1853).
Page 86: The ghost of Taira-no-Tomomori, played by actor Ichikawa Danjuro; *kabuki* art by Kunichika (1898).
Page 87: Yoshitsune's ship attacked by the Taira ghosts, from the series **Life Of Yoshitsune**; art by Kuniyoshi (1853).

YUKI-ONNA

Mosaku and his apprentice Minokichi journeyed to a forest, some little distance from their village. It was a bitterly cold night when they neared their destination, and saw in front of them a cold sweep of water. They desired to cross this river, but the ferryman had gone away, leaving his boat on the other side of the water, and as the weather was too inclement to admit of swimming across the river they were glad to take shelter in the ferryman's little hut.

Mosaku fell asleep almost immediately he entered this humble but welcome shelter. Minokichi, however, lay awake for a long time listening to the cry of the wind and the hiss of the snow as it was blown against the door.

Minokichi at last fell asleep, to be soon awakened by a shower of snow falling across his face. He found that the door had been blown open, and that standing in the room was a fair woman in dazzlingly white garments. For a moment she stood thus; then she bent over Mosaku, her breath coming forth like white smoke. After bending thus over the old man for a minute or two she turned to Minokichi and hovered over him. He tried to cry out, for the breath of this woman was like a freezing blast of wind. She told him that she had intended to treat him as she had done the old man at his side, but forbore on account of his youth and beauty. Threatening Minokichi with instant death if he dared to mention to anyone what he had seen, she suddenly vanished.

Then Minokichi called out to his beloved master, "Mosaku, Mosaku, wake! Something very terrible has happened!" But there was no reply. He touched the hand of his master in the dark, and found it was like a piece of ice. Mosaku was dead!

During the next winter, while Minokichi was returning home, he chanced to meet a pretty girl by the name of Yuki. She informed him that she was going to Yedo, where she desired to find a situation as a servant. Minokichi was charmed with this maiden, and he went so far as to ask if she were betrothed, and hearing that she was not, he took her to his own home, and in due time married her.

Yuki presented her husband with ten fine and handsome children, fairer of skin than average. When Minokichi's mother died, her last words were in praise of Yuki, and her eulogy was echoed by many of the country folk in the district.

One night, while Yuki was sewing, the light of a paper lamp shining upon her face, Minokichi recalled the extraordinary experience he had had in the ferryman's hut.

"Yuki," said he, "you remind me so much of a beautiful white woman I saw when I was eighteen years old. She killed my master with her ice-cold breath. I am sure she was some strange spirit, and yet tonight she seems to resemble you."

Yuki flung down her sewing. There was a horrible smile on her face as she bent close to her husband and shrieked, "It was I, Yuki-Onna, who came to you then, and silently killed your master! Oh, faithless wretch, you have broken your promise to keep the matter secret, and if it were not for our sleeping children I would kill you now! Remember, if they have aught to complain of at your hands I shall hear, I shall know, and on a night when the snow falls I will kill you!"

Then Yuki-Onna, the Lady of the Snow, changed into a white mist, and, shrieking and shuddering, passed through the smoke-hole, never to return again.

ILLUSTRATION
Page 88: Yuki-Onna, from the **Bakemono Zukushi** (painted handscroll); artist unknown (c.1800).

ROKURO-KUBI

Nearly five hundred years ago there was a samurai, named Isogai Heidazaemon Taketsura, in the service of the Lord Kikuji, of Kyushu. This Isogai had inherited, from many warlike ancestors, a natural aptitude for military exercises, and extraordinary strength. While yet a boy he had surpassed his teachers in the art of swordsmanship, in archery, and in the use of the spear, and had displayed all the capacities of a daring and skillful soldier. Afterwards, in the time of the Eikyo war, he so distinguished himself that high honors were bestowed upon him. But when the house of Kikuji came to ruin, Isogai found himself without a master. He might then easily have obtained service under another daimyo; but as he had never sought distinction for his own sake alone, and as his heart remained true to his former lord, he preferred to give up the world. so he cut off his hair, and became a traveling priest, – taking the Buddhist name of Kwairyo.

But always, under the koromo of the priest, Kwairyo kept warm within him the heart of the samurai. As in other years he had laughed at peril, so now also he scorned danger; and in all weathers and all seasons he journeyed to preach the good Law in places where no other priest would have dared to go. For that age was an age of violence and disorder; and upon the highways there was no security for the solitary traveler, even if he happened to be a priest.

In the course of his first long journey, Kwairyo had occasion to visit the province of Kai. One evening, as he was traveling through the mountains of that province, darkness overcame him in a very lonesome district, leagues away from any village. So he resigned himself to pass the night under the stars; and having found a suitable grassy spot, by the roadside, he lay down there, and prepared to sleep. He had always welcomed discomfort; and even a bare rock was for him a good bed, when nothing better could be found, and the root of a pine-tree an excellent pillow. His body was iron; and he never troubled himself about dews or rain or frost or snow.

Scarcely had he lain down when a man came along the road, carrying an axe and a great bundle of chopped

wood. This woodcutter halted on seeing Kwairyo lying down, and, after a moment of silent observation, said to him in a tone of great surprise:

"What kind of a man can you be, good Sir, that you dare to lie down alone in such a place as this?... There are haunters about here, – many of them. are you not afraid of Hairy Things?"

"My friend," cheerfully answered Kwairyo, "I am only a wandering priest – a 'Cloud-and-Water-Guest,' as folks call it: Unsui-no-ryokaku. And I am not in the least afraid of Hairy Things, – if you mean goblin-foxes, or goblin-badgers, or any creatures of that kind. As for lonesome places, I like them: they are suitable for meditation. I am accustomed to sleeping in the open air: and I have learned never to be anxious aboutmy life."

"You must be indeed a brave man, Sir Priest," the peasant responded, "to lie down here! This place has a bad name, – a very bad name. But, as the proverb has it, Kunshi ayayuki ni chikayorazu ['The superior man does not needlessly expose himself to peril']; and I must assure you, Sir, that it is very dangerous to sleep here. Therefore, although my house is only a wretched thatched hut, let me beg of you to come home with me at once. In the way of food, I have nothing to offer you; but there is a roof at least, and you can sleep under it without risk."

He spoke earnestly; and Kwairyo, liking the kindly tone of the man, accepted this modest offer. The woodcutter guided him along a narrow path, leading up from the main road through mountain-forest. It was a rough and dangerous path, – sometimes skirting precipices, – sometimes offering nothing but a network of slippery roots for the foot to rest upon, – sometimes winding over or between masses of jagged rock. But at last Kwairyo found himself upon a cleared space at the top of a hill, with a full moon shining overhead; and he saw before him a small thatched cottage, cheerfully lighted from within. The woodcutter led him to a shed at the back of the house, whither water had been conducted, through bamboo-pipes, from some neighboring stream; and the two men washed their feet. Beyond the shed was a vegetable garden, and a grove of cedars and bamboos; and beyond the trees appeared the glimmer of a cascade, pouring from some loftier height, and swaying in the moonshine like a long white robe.

As Kwairyo entered the cottage with his guide, he perceived four persons – men and women – warming their hands at a little fire kindled in the oven of the principle apartment. They bowed low to the priest, and greeted him in the most respectful manner. Kwairyo wondered that persons so poor, and dwelling in such a solitude, should be aware of the polite forms of greeting. "These are good people," he thought to himself; "and they must have been taught by some one well acquainted with the rules of propriety." Then turning to his host, – the aruji, or house-master, as the others called him, – Kwairyo said:

"From the kindness of your speech, and from the very polite welcome given me by your household, I imagine that you have not always been a woodcutter. Perhaps you formerly belonged to one of the upper classes?"

Smiling, the woodcutter answered:

"Sir, you are not mistaken. Though now living as you find me, I was once a person of some distinction. My story is the story of a ruined life – ruined by my own fault. I used to be in the service of a daimyo; and my rank in that service was not inconsiderable. But I loved women and wine too well; and under the influence of passion I acted wickedly. My selfishness brought about the ruin of our house, and caused the death of many persons. Retribution followed me; and I long remained a fugitive in the land. Now I often pray that I may be able to make some atonement for the evil which I did, and to reestablish the ancestral home. But I fear that I shall never find any way of so doing. Nevertheless, I try to overcome the karma of my errors by sincere repentance, and by helping as afar as I can, those who are unfortunate."

Kwairyo was pleased by this announcement of good resolve; and he said to the aruji:

"My friend, I have had occasion to observe that man, prone to folly in their youth, may in after years become

very earnest in right living. In the holy sutras it is written that those strongest in wrong-doing can become, by power of good resolve, the strongest in right-doing. I do not doubt that you have a good heart; and I hope that better fortune will come to you. To-night I shall recite the sutras for your sake, and pray that you may obtain the force to overcome the karma of any past errors."

With these assurances, Kwairyo bade the aruji good-night; and his host showed him to a very small side-room, where a bed had been made ready. Then all went to sleep except the priest, who began to read the sutras by the light of a paper lantern. Until a late hour he continued to read and pray: then he opened a little window in his little sleeping-room, to take a last look at the landscape before lying down. The night was beautiful: there was no cloud in the sky: there was no wind; and the strong moonlight threw down sharp black shadows of foliage, and glittered on the dews of the garden. Shrillings of crickets and bell-insects (3) made a musical tumult; and the sound of the neighboring cascade deepened with the night. Kwairyo felt thirsty as he listened to the noise of the water; and, remembering the bamboo aqueduct at the rear of the house, he thought that he could go there and get a drink without disturbing the sleeping household. Very gently he pushed apart the sliding-screens that separated his room from the main apartment; and he saw, by the light of the lantern, five recumbent bodies – without heads!

For one instant he stood bewildered, – imagining a crime. But in another moment he perceived that there was no blood, and that the headless necks did not look as if they had been cut. Then he thought to himself: – "Either this is an illusion made by goblins, or I have been lured into the dwelling of a Rokuro-Kubi... (4) In the book Soshinki (5) it is written that if one find the body of a Rokuro-Kubi without its head, and remove the body to another place, the head will never be able to join itself again to the neck. And the book further says that when the head comes back and finds that its body has been moved, it will strike itself upon the floor three times, – bounding like a ball, – and will pant as in great fear, and presently die. Now, if these be Rokuro-Kubi, they mean me no good; – so I shall be justified in following the instructions of the book."...

He seized the body of the aruji by the feet, pulled it to the window, and pushed it out. Then he went to the back-door, which he found barred; and he surmised that the heads had made their exit through the smoke-hole in the roof, which had been left open. Gently unbarring the door, he made his way to the garden, and proceeded with all possible caution to the grove beyond it. He heard voices talking in the grove; and he went in the direction of the voices, – stealing from shadow to shadow, until he reached a good hiding-place. Then, from behind a trunk, he caught sight of the heads, – all five of them, – flitting about, and chatting as they flitted. They were eating worms and insects which they found on the ground or among the trees. Presently the head of the aruji stopped eating and said:

"Ah, that traveling priest who came to-night! – how fat all his body is! When we shall have eaten him, our bellies will be well filled... I was foolish to talk to him as I did; – it only set him to reciting the sutras on behalf of my soul! To go near him while he is reciting would be difficult; and we cannot touch him so long as he is praying. But as it is now nearly morning, perhaps he has gone to sleep... Some one of you go to the house and see what the fellow is doing."

Another head – the head of a young woman – immediately rose up and flitted to the house, lightly as a bat. After a few minutes it came back, and cried out huskily, in a tone of great alarm:

"That traveling priest is not in the house; – he is gone! But that is not the worst of the matter. He has taken the body of our aruji; and I do not know where he has put it."

At this announcement the head of the aruji – distinctly visible in the moonlight – assumed a frightful aspect: its eyes opened monstrously; its hair stood up bristling; and its teeth gnashed. Then a cry burst from its lips; and – weeping tears of rage – it exclaimed:

"Since my body has been moved, to rejoin it is not possible! Then I must die!... And all through the work of that priest! Before I die I will get at that priest! – I will tear him! – I will devour him!... AND THERE HE IS – behind that tree! – hiding behind that tree! See him ! – the fat coward!"...

In the same moment the head of the aruji, followed by the other four heads, sprang at Kwairyo. But the strong priest had already armed himself by plucking up a young tree; and with that tree he struck the heads as they came, knocking them from him with tremendous blows. Four of them fled away. But the head of the aruji, though battered again and again, desperately continued to bound at the priest, and at last caught him by the left sleeve of his robe. Kwairyo, however, as quickly gripped the head by its topknot, and repeatedly struck it. It did not release its hold; but it uttered a long moan, and thereafter ceased to struggle. It was dead. But its teeth still held the sleeve; and, for all his great strength, Kwairyo could not force open the jaws.

With the head still hanging to his sleeve he went back to the house, and there caught sight of the other four Rokuro-Kubi squatting together, with their bruised and bleeding heads reunited to their bodies. But when they perceived him at the back-door all screamed, "The priest! the priest!" – and fled, through the other doorway, out into the woods.

Eastward the sky was brightening; day was about to dawn; and Kwairyo knew that the power of the goblins was limited to the hours of darkness. He looked at the head clinging to his sleeve, – its face all fouled with blood and foam and clay; and he laughed aloud as he thought to himself: "What a miyage! [4] – the head of a goblin!" After which he gathered together his few belongings, and leisurely descended the mountain to continue his journey.

Right on he journeyed, until he came to Suwa in Shinano; (6) and into the main street of Suwa he solemnly strode, with the head dangling at his elbow. Then woman fainted, and children screamed and ran away; and there was a great crowding and clamoring until the torite (as the police in those days were called) seized the priest, and took him to jail. For they supposed the head to be the head of a murdered man who, in the moment of being killed, had caught the murderer's sleeve in his teeth. As the Kwairyo, he only smiled and said nothing when they questioned him. So, after having passed a night in prison, he was brought before the magistrates of the district. Then he was ordered to explain how he, a priest, had been found with the head of a man fastened to his sleeve, and why he had dared thus shamelessly to parade his crime in the sight of people.

Kwairyo laughed long and loudly at these questions; and then he said:

"Sirs, I did not fasten the head to my sleeve: it fastened itself there – much against my will. And I have not committed any crime. For this is not the head of a man; it is the head of a goblin; – and, if I caused the death of the goblin, I did not do so by any shedding of blood, but simply by taking the precautions necessary to assure my own safety."... And he proceeded to relate the whole of the adventure, – bursting into another hearty laugh as he told of his encounter with the five heads.

But the magistrates did not laugh. They judged him to be a hardened criminal, and his story an insult to their intelligence. Therefore, without further questioning, they decided to order his immediate execution, – all of them except one, a very old man. This aged officer had made no remark during the trial; but, after having heard the opinion of his colleagues, he rose up, and said: –

"Let us first examine the head carefully; for this, I think, has not yet been done. If the priest has spoken truth, the head itself should bear witness for him... Bring the head here!"

So the head, still holding in its teeth the koromo that had been stripped from Kwairyo's shoulders, was put before the judges. The old man turned it round and round, carefully examined it, and discovered, on the nape of its neck, several strange red characters. He called the attention of his colleagues to these, and also bad them observe that the edges of the neck nowhere presented the appearance of having been cut by any weapon. On the contrary, the line of leverance was smooth as the line at which a falling leaf detaches itself from the stem... Then said the elder:

"I am quite sure that the priest told us nothing but the truth. This is the head of a Rokuro-Kubi. In the book Nan-ho-i-butsu-shi it is written that certain red characters can always be found upon the nape of the neck of a real

Rokuro-Kubi. There are the characters: you can see for yourselves that they have not been painted. Moreover, it is well known that such goblins have been dwelling in the mountains of the province of Kai from very ancient time... But you, Sir," he exclaimed, turning to Kwairyo, – "what sort of sturdy priest may you be? Certainly you have given proof of a courage that few priests possess; and you have the air of a soldier rather than a priest. Perhaps you once belonged to the samurai-class?"

"You have guessed rightly, Sir," Kwairyo responded. "Before becoming a priest, I long followed the profession of arms; and in those days I never feared man or devil. My name then was Isogai Heidazaemon Taketsura of Kyushu: there may be some among you who remember it." At the mention of that name, a murmur of admiration filled the court-room.; for there were many present who remembered it. And Kwairyo immediately found himself among friends instead of judges, – friends anxious to prove their admiration by fraternal kindness. With honor they escorted him to the residence of the daimyo, who welcomed him, and feasted him, and made him a handsome present before allowing him to depart. When Kwairyo left Suwa, he was as happy as any priest is permitted to be in this transitory world. As for the head, he took it with him, – jocosely insisting that he intended it for a miyage.

And now it only remains to tell what became of the head.

A day or two after leaving Suwa, Kwairyo met with a robber, who stopped him in a lonesome place, and bade him strip. Kwairyo at once removed his koromo, and offered it to the robber, who then first perceived what was hanging to the sleeve. Though brave, the highwayman was startled: he dropped the garment, and sprang back. Then he cried out: – "You! – what kind of a priest are you? Why, you are a worse man than I am! It is true that I have killed people; but I never walked about with anybody's head fastened to my sleeve... Well, Sir priest, I suppose we are of the same calling; and I must say that I admire you!... Now that head would be of use to me: I could frighten people with it. Will you sell it? You can have my robe in exchange for your koromo; and I will give you five ryo for the head."

Kwairyo answered: "I shall let you have the head and the robe if you insist; but I must tell you that this is not the head of a man. It is a goblin's head. So, if you buy it, and have any trouble in consequence, please to remember that you were not deceived by me." "What a nice priest you are!" exclaimed the robber. "You kill men, and jest about it!... But I am really in earnest. Here is my robe; and here is the money; – and let me have the head... What is the use of joking?"

"Take the thing," said Kwairyo. "I was not joking. The only joke – if there be any joke at all – is that you are fool enough to pay good money for a goblin's head." And Kwairyo, loudly laughing, went upon his way.

Thus the robber got the head and the koromo; and for some time he played goblin-priest upon the highways. But, reaching the neighborhood of Suwa, he there leaned the true story of the head; and he then became afraid that the spirit of the Rokuro-Kubi might give him trouble. So he made up his mind to take back the head to the place from which it had come, and to bury it with its body. He found his way to the lonely cottage in the mountains of Kai; but nobody was there, and he could not discover the body. Therefore he buried the head by itself, in the grove behind the cottage; and he had a tombstone set up over the grave; and he caused a Segaki-service to be performed on behalf of the spirit of the Rokuro-Kubi. And that tombstone – known as the Tombstone of the Rokuro-Kubi – may be seen (at least so the Japanese story-teller declares) even unto this day.

ILLUSTRATIONS
Page 90: Rokuro-Kubi (detail from diptych); art by Kunisada (c.1841).
Page 91: Rokuro-kubi; art by Kuniyoshi, from the kabuki play **Kasane ogi chiyo no Matsuwaka** (1841).
Page 94: Rokuro-Kubi; art by Toyokuni I (1813).
Page 96: Rokuro-Kubi; art by Toyokuni I (c.1820).

YORIMASA AND THE NUE

Genzan Yorimasa was a brave warrior and a very useful man who lived more than eight thousand moons ago. On account of his valor and skill in the use of the bow he was called to Kyoto, and promoted to be chief guard of the imperial palace. At that time the emperor, Narahito, could not sleep at night, because his rest was disturbed by a frightful beast, the Nue, which scared away even the sentinels in armor who stood on guard. This dreadful beast had the wings of a bird, the body and claws of a tiger, the head of a monkey, a serpent tail, and the crackling scales of a dragon. It came after night, upon the roof of the palace, and howled and scratched so dreadfully, that the poor mikado losing all rest, grew weak and thin. None of the guards dare face it in hand-to-hand fight, and none had skill enough to hit it with an arrow in the dark, though several of the imperial corps of archers had tried again and again. When Yorimasa received his appointment, he strung his bow carefully, and carefully honing his steel-headed arrows, stored his quiver, and resolved to mount guard that night with his favorite retainer.

It chanced to be a stormy night. The lightning was very vivid, and Kaminari, the thunder-god was beating all his drums. The wind swirled round frightfully, as though Fuden the wind-god was emptying all his bags. Toward midnight, the falcon eye of Yorimasa saw, during a flash of lightning, the awful beast sitting on the "devil's tile" at the tip of the ridge-pole, on the north-east end of the roof. He bade his retainer have a torch of straw and twigs ready to light at a moment's notice, to loosen his blade, and wet its hilt-pin, while he fitted the notch of his best arrow into the silk cord of his bow.

Keeping his eyes strained, he pretty soon saw the glare now of one eye, now two eyes, as the beast with swaying head crept along the great roof to the place on the eaves directly under the mikado's sleeping-room. There it stopped. This was Yorimasa's opportunity. Aiming about a foot to the right of where he saw the eye glare, he drew his yard-length shaft clear back to his shoulder, and let fly. A dull thud, a frightful howl, a heavy bump on the ground, and the writhing of some creature among the pebbles, told in a few seconds time that the shaft had struck flesh. The next instant Yorimasa's retainer rushed out with blazing torch and joined battle with his dirk. Seizing the Nue by the neck, he quickly despatched him, by cutting his throat. Then they flayed the monster, and the next morning the hide was shown to his majesty.

All congratulated Yorimasa on his valor and marksmanship. Many young men, sons of nobles and warriors, begged to become his pupils in archery. The mikado ordered a noble of very high rank to present to Yorimasa a famous sword named Shishi-no-o (King of Wild Boars), and to give him a lovely maid of honor named Ayami, to wife. And so the brave and the fair were married, and to this day the fame of Yorimasa is like the "umé-také-matsu", (plum-blossom, bamboo and pine), fragrant, green and ever-during.

ILLUSTRATION
Page 98: The Nue, descending in a thundercloud towards the imperial palace; art by Kuniyoshi, from the series **69 Stations Of The Kisokaido Road** (1852).

JIRAIYA

Ogata was the name of a castle-lord who lived in the Island of the Nine Provinces, (Kiushiu). He had but one son, an infant, whom the people in admiration nicknamed Jiraiya (Young Thunder.) During one of the civil wars, this castle was taken, and Ogata was slain; but by the aid of a faithful retainer, who hid Jiraiya in his bosom, the boy escaped and fled northward to Echigo. There he lived until he grew up to manhood.

At that time Echigo was infested with robbers. One day the faithful retainer of Jiraiya being attacked, made resistance, and was slain by the robbers. Jiraiya now left alone in the world went out from Echigo and led a wandering life in several provinces.

All this time he was consumed with the desire to revive the name of his father, and restore the fortunes of his family. Being exceedingly brave, and an expert swordsman, he became chief of a band of robbers and plundered many wealthy merchants, and in a short time he was rich in men, arms and booty. He was accustomed to disguise himself, and go in person into the houses and presence of men of wealth, and thus learn all about their gates and guards, where they slept, and in what rooms their treasures were stored, so that success was easy.

Hearing of an old man who lived in Shinano, he started to rob him, and for this purpose put on the disguise of a pilgrim. Shinano is a very high table-land, full of mountains, and the snow lies deep in winter. A great snow storm coming on, Jiraiya took refuge in a humble house by the way. Entering, he found a very beautiful woman, who treated him with great kindness. This, however, did not change the robber's nature. At midnight, when all was still, he unsheathed his sword, and going noiselessly to her room, he found the lady absorbed in reading.

Lifting his sword, he was about to strike at her neck, when, in a flash, her body changed into that of a very old man, who seized the heavy steel blade and broke it in pieces as though it were a stick. Then he tossed the bits of steel away, and thus spoke to Jiraiya, who stood amazed but fearless:

"I am a man named Senso Dojin, and I have lived in these mountains many hundred years, though my true

body is that of a huge frog. I can easily put you to death but I have another purpose. So I shall pardon you and teach you magic instead."

Then the youth bowed his head to the floor, poured out his thanks to the old man and begged to be received as his pupil.

Remaining with the old man of the mountain for several weeks, Jiraiya learned all the arts of the mountain spirits; how to cause a storm of wind and rain, to make a deluge, and to control the elements at will.

He also learned how to govern the frogs, and at his bidding they assumed gigantic size, so that on their backs he could stand up and cross rivers and carry enormous loads.

When the old man had finished instructing him he said "Henceforth cease from robbing, or in any way injuring the poor. Take from the wicked rich, and those who acquire money dishonestly, but help the needy and the suffering." Thus speaking, the old man turned into a huge frog and hopped away.

What this old mountain spirit bade him do, was just what Jiraiya wished to accomplish. He set out on his journey with a light heart. "I can now make the storm and the waters obey me, and all the frogs are at my command; but alas! the magic of the frog cannot control that of the serpent. I shall beware of his poison."

From that time forth the oppressed poor people rejoiced many a time as the avaricious merchants and extortionate money lenders lost their treasures. For when a poor farmer, whose crops failed, could not pay his rent or loan on the date promised, these hard-hearted money lenders would turn him out of his house, seize his beds and mats and rice-tub, and even the shrine and images on the god-shelf, to sell them at auction for a trifle, to their minions, who resold them at a high price for the money-lender, who thus got a double benefit. Whenever a miser was robbed, the people said, "The young thunder has struck," and then they were glad, knowing that it was Jiraiya, (Young Thunder.) In this manner his name soon grew to be the poor people's watchword in those troublous times.

Yet Jiraiya was always ready to help the innocent and honest, even if they were rich. One day a merchant named Fukutaro was sentenced to death, though he was really not guilty. Jiraiya hearing of it, went to the magistrate and said that he himself was the very man who committed the robbery. So the man's life was saved, and Jiraiya was hanged on a large oak tree. But during the night, his dead body changed into a bull-frog which hopped away out of sight, and off into the mountains of Shinano.

At this time, there was living in this province, a young and beautiful maiden named Tsunadé. Her character was very lovely. She was always obedient to her parents and kind to her friends. Her daily task was to go to the mountains and cut brushwood for fuel. One day while thus busy singing at the task, she met a very old man, with a long white beard sweeping his breast, who said to her:

"Do not fear me. I have lived in this mountain many hundred years, but my real body is that of a snail. I will teach you the powers of magic, so that you can walk on the sea, or cross a river however swift and deep, as though it were dry land."

Gladly the maiden took daily lessons of the old man, and soon was able to walk on the waters as on the mountain paths. One day the old man said, "I shall now leave you and resume my former shape. Use your power to destroy wicked robbers. Help those who defend the poor. I advise you to marry the celebrated man Jiraiya, and thus you will unite your powers."

Thus saying, the old man shrivelled up into a snail and crawled away.

"I am glad," said the maiden to herself, "for the magic of the snail can overcome that of the serpent. When Jiraiya, who has the magic of the frog, shall marry me, we can then destroy the son of the serpent, the robber named Dragon-coil (Orochimaru)."

By good fortune, Jiraiya met the maiden Tsunadé, and being charmed with her beauty, and knowing her power of magic, sent a messenger with presents to her parents, asking them to give him their daughter to wife. The parents agreed, and so the young and loving couple were married.

Hitherto when Jiraiya wished to cross a river he changed himself into a frog and swam across; or, he summoned a bull-frog before him, which increased in size until as large as an elephant. Then standing erect on his warty back, even though the wind blew his garments wildly, Jiraiya reached the opposite shore in safety. But now, with his wife's powers, the two, without any delay, walked over as though the surface was a hard floor.

Soon after their marriage, war broke out in Japan between the two famous clans of Tsukikagé and Inukagé. To help them fight their battles, and capture the castles of their enemies, the Tsukikagé family besought the aid of Jiraiya, who agreed to serve them and carried their banner in his back. Their enemies, the Inukagé, then secured the services of Dragon-coil.

This Orochimaru, or Dragon-coil, was a very wicked robber whose father was a man, and whose mother was a serpent that lived in the bottom of Lake Takura. He was perfectly skilled in the magic of the serpent, and by spurting venom on his enemies, could destroy the strongest warriors.

Collecting thousands of followers, he made great ravages in all parts of Japan, robbing and murdering good and bad, rich and poor alike. Loving war and destruction he joined his forces with the Inukagé family.

Now that the magic of the frog and snail was joined to the one army, and the magic of the serpent aided the other, the conflicts were bloody and terrible, and many men were slain on both sides.

On one occasion, after a hard fought battle, Jiraiya fled and took refuge in a monastery, with a few trusty

vassals, to rest a short time. In this retreat a lovely princess named Tagoto was dwelling. She had fled from Orochimaru, who wished her for his bride. She hated to marry the offspring of a serpent, and hoped to escape him. She lived in fear of him continually. Orochimaru hearing at one time that both Jiraiya and the princess were at this place, changed himself into a serpent, and distilling a large mouthful of poisonous venom, crawled up to the ceiling in the room where Jiraiya and his wife were sleeping, and reaching a spot directly over them, poured the poisonous venom on the heads of his rivals. The fumes of the prison so stupefied Jiraiya's followers, and even the monks, that Orochimaru, instantly changing himself to a man, profited by the opportunity to seize the princess Tagoto, and make off with her.

Gradually the faithful retainers awoke from their stupor to find their master and his beloved wife delirious, and near the point of death, and the princess gone.

"What can we do to restore our dear master to life?" This was the question each one asked of the others, as with sorrowful faces and weeping eyes they gazed at the pallid forms of their unconscious master and his consort. They called in the venerable abbot of the monastery to see if he could suggest what could be done.

"Alas!" said the aged priest, "there is no medicine in Japan to cure your lord's disease, but in India there is an elixir which is a sure antidote. If we could get that, the master would recover."

"Alas! alas!" and a chorus of groans showed that all hope had fled, for the mountain in India, where the elixir was made, lay five thousand miles from Japan.

Just then a youth named Rikimatsu, one of the pages of Jiraiya, arose to speak. He was but fourteen years old, and served Jiraiya out of gratitude, for he had rescued his father from many dangers and saved his life. He begged permission to say a word to the abbot, who, seeing the lad's eager face, motioned to him with his fan to speak.

"How long can our lord live," asked the youth.

"He will be dead in thirty hours," answered the abbot, with a sigh.

"I'll go and procure the medicine, and if our master is still living when I come back, he will get well."

Now Rikimatsu had learned magic and sorcery from the Tengus, or long-nosed elves of the mountains, and could fly high in the air with incredible swiftness. Speaking a few words of incantation, he put on the wings of a Tengu, mounted a white cloud and rode on the east wind to India, bought the elixir of the mountain spirits, and returned to Japan in one day and a night.

On the first touch of the elixir on the sick man's face he drew a deep breath, perspiration glistened on his forehead, and in a few moments more he sat up.

Jiraiya and his wife both got well, and the war broke out again. In a great battle Dragon-coil was killed and the princess rescued. For his prowess and aid Jiraiya was made daimio of Idzu.

Being now weary of war and the hardships of active life, Jiraiya was glad to settle down to tranquil life in the castle and rear his family in peace. He spent the remainder of his days in reading the books of the sages, in composing verses, in admiring the flowers, the moon and the landscape, and occasionally going out hawking or fishing. There, amid his children and children's children, he finished his days in peace.

ILLUSTRATIONS
Page 100: Jiraiya battling a huge snake; art by Yoshitsuya (c.1858).
Page 101: Jiraiya and Orochimaru battling atop a giant toad; art by Kuniyoshi (1852).
Page 103: Actor Ichikawa Danjûrô VIII as Jiraiya; *kabuki* art by Kunisada (1852).
Page 104: Jiraiya (left picture) and Orochimaru (right picture); art by Kunisada, from the series **A Contest Of Magic** (1862).

THE ADVENTURES OF RAIKO

THE OGRE SHUTENDOJI

Long, long ago in Old Japan, in the reign of the Emperor Ichijo, the sixty-sixth Emperor, there lived a very brave general called Minamoto-no-Raiko. Minamoto was the name of the powerful clan to which he belonged, and Raiko (also pronounced as Yorimitsu) was his own name.

In those times it was the custom for generals to keep as a body-guard four picked knights renowned for their daring spirit, their great strength, and their skill in wielding the sword. These four braves were called Shitenno, or Four Kings of Heaven, and they participated in all the exploits and martial expeditions of their chief, and vied with one another in excelling in bravery and dexterity.

Minamoto-no-Raiko was no exception to the general rule of those ancient leaders of Japan, and he had under him Usui Sadamitsu, Sakata Kintoki, Urabe Suetake, and Watanabe Tsuna. Search the wide world from north to south and from east to west, and no braver warriors than the Shitenno of Minamoto-no-Raiko could you find. Each one of the four was said to be a match single-handed for a thousand men. They lived for adventure, and their delight was in war.

Now it happened about this time that Kyoto, the capital, was ringing with the stories of the doings of a frightful ogre that lived in the fastnesses of a high mountain called Mount Oye, in the province of Tamba. This demon's name was Shutendoji. To look upon the creature was a horrible thing, and those who once caught sight of him never forgot the sight to their dying day. He sometimes took upon him the form of a human being, and leaving his den would steal into the capital and haunt the streets and carry off precious sons and beloved daughters of the Kyoto homes. Having seized these treasures and flowers of the people, he would drag them to his castle in the wilds of Mount Oye, and there he would make them work and wait upon him till he was ready to devour them, then he would tear them limb from limb.

For a long time the flower of the youth of the capital had been kidnapped in this way; many homes had been made desolate. For a long, long time no one had the least idea of what happened to the sons and daughters thus stolen, but at the period when this story begins, the dread news of the cannibal Shutendoji and his mountain den began to be noised abroad.

Now at the Court there was an official, Knight Kimitaka by name, who was thrice happy in the possession of a beautiful daughter. She was his only child, and upon her he and his wife doted. One day the darling of the family disappeared, and no trace whatsoever of the beautiful girl could be found. The household was plunged into the deepest grief and misery. The mother at last determined to consult a soothsayer, and, bidding an attendant follow her, she repaired to the house of a famous fortune-teller and diviner, who revealed to her that her daughter had been stolen away by the ogre of Mount Oye. The mother hastened home terror-stricken, and the father, when he was told the dire news, was dumb with grief. He gave up going on duty at the Palace, for he was so broken-hearted that he could do nothing but weep night and day over the loss of his only daughter. To lose her was bad enough, but the thought of the horrible hands into which she had fallen was unendurable, and all who loved the poor child, even her own father, were powerless to save her. Oh! the bitter, bitter grief!

At last the Emperor heard of the sorrow that Raiko told them of the expedition, and explained that, as the demon was no common foe, he thought it wise that they should go to his mountain in disguise; in this way they would the more likely and the more easily overcome the ogre. They all agreed to what their chief said and set about making their preparations with great joy. They polished up their armour and sharpened their long swords and tried on their helmets, rejoicing in the prospect of the action confronting them. Before starting on this dangerous enterprise, they thought it wise to seek the protection and blessing of the gods, so Raiko and Yasumasa went to pray for help at the Temple of Hachiman, the God of War, at Mount Otoko, while Tsuna and Kintoki went to the Sumiyoshi Shrine of the Goddess of Mercy, and Sadamitsu and Suetake to the Temple of Gongen at Kumano. At each shrine the six knights offered up the same prayer for divine help and strength, and on bended knees and with hands laid palm to palm they besought the gods to grant them success in their expedition and a safe return to the capital.

Then the brave band disguised themselves as mountain priests. They wore priests' caps and sacerdotal garments and stoles; they hid their armour and their helmets and their weapons in the knapsacks they carried on their backs; in their right hands they carried a pilgrim's staff, and in their left a rosary, and they wore rough straw sandals on their feet. No one meeting these dignified, solemn-looking priests would have thought that they were on the way to attack the ogre of Mount Oye, and no one would have dreamt that the leader of the band was the warrior Raiko, who for courage and strength had not his peer in the whole of the Island Empire.

In this way Raiko and his men travelled across the country till at last they reached the province of Tamba and came to the foot of the mountain of Oye. Now as the ogre had chosen Mount Oye as his place of abode, you can imagine how difficult of access it was! Raiko and his men had often travelled in mountainous districts, but they had never experienced anything like the steepness of Mount Oye. It was indescribable. Great rocks obstructed the way, and the branches of the trees were so thickly interlaced overhead that the light of day could not penetrate through the foliage even at midday, and the shadows were so black that the warriors would have been glad of lanterns. Sometimes the path led them over precipices where they could hear the water rushing along the deep ravines beneath. So deep were these chasms that as Raiko and his men passed them they were overcome with giddiness. For the first time they realized now the dangers and difficulties of the task they had undertaken, and they were somewhat disheartened. At times they rested themselves on the roots of trees to gain breath, sometimes they stopped to quench their thirst at some trickling spring, catching the water up in their hands. They did not, however, allow themselves to be discouraged long,

but pushed their way deeper and deeper into the mountain, encouraging each other with brave words of cheer when they felt their spirits flagging. But the thought sometimes crossed their minds, though they one and all kept it to themselves, "What if Shutendoji, or some of his demons, should be lurking behind any of the rocks or cliffs?"

Suddenly from behind a rock three old men appeared. Now Raiko, who was as wise as he was brave, and who at that very moment had been thinking of what he should do were they to encounter the ogre unexpectedly, thought that sure enough here were some of the cannibal's goblins, who had heard of his approach. They had simply disguised themselves as these venerable old men so as to deceive him and his men! But he was not to be outwitted by any such prank. He made signs with his eyes to the men behind him to he on their guard, and they in obedience to his gesture put themselves in attitudes of defence.

The three old men saw at once the mistake Raiko had made, for they smiled at him and then drawing nearer, they bowed before him, and the foremost one said: "Do not be afraid of us; we are not the goblins of this mountain. I am from the province of Settsu. My friend is from Ku, and the third lives near the capital. We have all been bereft of our beloved wives and daughters by Shutendoji the ogre. Because of our great age we can do nothing to help them, though our sorrow for their loss, instead of growing less, grows greater day by day. We have heard of your coming, and we have awaited you here, so that we might ask you to help us in our distress. It is a great favour we ask, but we entreat you if you encounter Shutendoji to show him no mercy, but to slay him and so avenge the wrongs of our wives and children and many others who have been torn away from their homes in the Flower Capital."

Raiko listened attentively to all the old man said, and then answered: "Now that you have told me so much, I need not reserve the truth from you;" and he went on to tell them of the order he had received from the Emperor to destroy Shutendoji and his den, and the warrior did his best to comfort the old men and to assure them that he would do all in his power to restore their kidnapped wives and daughters.

Then the old men expressed great joy; their faces beamed like the sun as they thanked Raiko warmly for his kind sympathy, and they presented him with a jar of saki, saying as they bowed low:

"As a token of our gratitude we wish to present you with this magic wine. It is called 'Shimben-Kidoku-Shu.' The name means, 'a cordial for men but a poison to goblins.' Therefore if a demon drinks of this wine, all his strength will go from him, and he will be as one paralyzed. Before you attack Shutendoji, give him to drink of this wine, and for the rest you will find no difficulty."

And with these words the venerable spokesman handed the warrior a small white stone jar containing the wine. As soon as Raiko had taken the jar into his hands, a radiance like that of sunlight suddenly shone round the old men, and they vanished upwards from sight till their shining figures were lost in the clouds.

The warriors were struck with astonishment. They gazed upwards as if stupefied. But Raiko was the first to recover from his surprise. He clapped his hands and laughed as he said: "Be not afraid at what you have seen! Be sure that the three who thus appeared to us are none other than the gods of the shrines we visited before starting on this perilous enterprise. The old man who said he was from Settsu must have been the deity of Sumiyoshi, the one from the province of Ku was the divinity of Kumano, and the one from the capital the god Hachiman of Mount Otoko. This is a most propitious sign. The three deities have taken us under their special protection. This saki is their gift, and it will surely be of magic power in helping us to overcome the demons. We must, therefore, render thanks to Heaven for the protection vouchsafed to us."

Then Raiko and his five knights knelt down on the mountain pass and bowed themselves to the ground and prayed for some minutes in silence, overcome with awe at the thought that the three gods whose aid they had invoked had visited them. Raiko sprang to his feet and lifted the jar of saki reverently above his head, then he placed it with

his armour and weapons in the box he carried on his back. Having done this, they all proceeded on their way, but oh I how safe and confident they now felt. Raiko with his magic wine felt more than a match for any demon now. There is a proverb which says, "A giant with an iron rod", which means strength added to strength, and this was fully illustrated in the case of Raiko. The ogre Shutendoji was now to be pitied; it would surely go hard with him!

As they sped on their way they came to a mountain stream, and here they found a damsel washing a blood-stained garment, and as she washed and beat the garment against the current, they saw that she often had to stop and wipe the tears away with her sleeve, for she was weeping bitterly. Raiko's heart was stirred with pity at her distress, and he went up to her and said: "This is a goblin-haunted mountain; how is it that I find a damsel such as you here?"

The Princess (for such she was) looked up in his face wonderingly and said: "It is indeed true that this is a goblin-haunted mountain, and hitherto inaccessible to mortals. How is it that you have managed to get here?" and she looked from Raiko to his men.

Then Raiko said: "I will tell you the truth quite frankly. The Emperor has commanded us to slay the demon; that is why we are here!"

Without waiting to hear any more, the Princess ran up to Raiko in her joy and clung to him, crying out in broken sentences: "Are you indeed the great Raiko of whom I have so often heard? How thankful I am that you have come. I will be your guide to the ogre's den. Hasten, Knight Raiko, and kill the demons! I already feel that I am saved!"

When they heard these words the warriors knew that she was one of the ogre's victims. The Princess turned and led the way up the hill. Presently they saw a large iron gate guarded by two demons. The demon on the right was red and the demon on the left was black, and each was armed with a great iron stick or club. The Princess whispered to Raiko: "Behold the home of the demon. Enter the gates, and you will find a beautiful palace, built of black iron from the foundations to the roof. It is therefore called the Palace of Black Iron or *Kurogane*. It is large, and the inside is as beautiful as a great Daimio's palace. Within the walls of the Palace of Black Iron, Shutendoji holds a feast night and day. He is waited upon by maidens such as I, whom he has carried off from the capital and from the provinces to be his slaves. The wine he drinks, poured out in crimson lacquer cups, is the blood of human beings, and the food

of those feasts is the flesh of his victims who are slain in turn. What numbers have I seen disappear, alas! all murdered to supply the awful food and wine of those cannibal feasts. How I have prayed to Heaven to punish this monster! But when I saw the fate of my friends, how could I hope to live? I knew not when my turn would come. But since I have met you I feel that we shall all be saved and great is my joy and gratitude!"

By this time they had reached the gate, and the Princess went forward and said to the red and black demon sentinels: "These poor travellers have lost their way on this mountain. I took compassion on them and brought them here, so that they may rest for a while before going on their journey. I hope you will be kind to them."

When the Princess first began to speak the demons looked and saw Raiko and his fellow priests. Little dreaming who these men were, and that in admitting them they were letting in the bravest knights in the whole of Japan, and still less suspecting their purpose, the demons laughed in their hearts. Good prey had indeed fallen into their hands; they would surely be allowed a share in the feast that these fresh victims would furnish.

They grinned from ear to ear at the Princess and told her that she had done well, and bade her take the six travellers into the Palace and inform Shutendoji of their arrival. Thus the six warriors entered into the very stronghold of the demons as if they were invited guests. Triumphant glee at the success of their plan made them exchange lightning glances with each other. They passed through the great iron gate, up to the porch, and then the Princess led them through large spacious rooms and along great corridors till at last they reached the inner part of the Palace. Here they were shown into a large hall. At the upper end in the seat of honour sat the demon king Shutendoji. Never had the knights in their wildest dreams dreamt of such a hideous monster. He was ten feet in height, his skin was bright red and his wild shock of hair was like a broom. He wore a crimson hakama, and he rested his huge arms on a stand. As the knights entered, he glared at them fiercely with eyes as big as a dish. The sight of this dread monster was enough to make any one tremble with fear, and had Raiko and his knights been weak they must have fainted away with horror.

Raiko could hardly restrain himself from flying at the monster then and there, but he controlled himself and bowed humbly so as not to awaken the enemy's suspicion in any way.

Shutendoji, glaring at him, said haughtily: "I do not know who you are in the least, or how you have found your way into this mountain, but make yourself at home!"

Then Raiko answered meekly: "We are only humble mountain priests from Mount Haguro of Dewa. We were on our way to the capital, having been on a pilgrimage to the shrine of Omine. In travelling across these mountains we have lost our way. While wandering about and wondering which was the right path to take, we were met by one of the inmates of your palace and kindly brought here. Please pardon us for trespassing on your domains and for all the trouble we are giving you!"

"Don't mention it," said Shutendoji; "I am sorry to hear of your plight. Do not stand on ceremony while you are here, and let us feast together." Then turning to the attendant demons he shouted orders for the dinner to be served, and clapped his red hands together.

At this the partitions between the rooms slid apart and beautiful damsels magnificently robed came gliding in, bearing aloft in their hands large wine-cups, jars of saki, and dishes of fish of all kinds, which they placed before the ugly ogre and the guests. Raiko knew that all these lovely princesses had been snatched from the Flower Capital by Shutendoji, who, heedless of their tears and misery, kept them here to be his handmaidens. He said to himself fiercely that they should soon be free.

Now that the wine-cups were brought in, the warrior seized his opportunity. From his satchel he took out the jar containing the enchanted wine, Shimben-Kidoku-Shu, which he had received from the gods of the three shrines,

and said to Shutendoji: "Here is some wine which we have brought from Mount Haguro. It is a poor wine and unworthy of your acceptance, but we have always found it of great benefit in refreshing us when we were weary from fatigue and in cheering our drooping spirits. It will give us much pleasure if you will try a little of our humble wine, though it may not please your taste!"

Shutendoji seemed pleased at this courtesy. He handed out a huge cup to be filled, saying: "Give me some of your wine. I should like to try it."

The ogre drained it at one swallow and smacked his lips over it. "I have never tasted such excellent wine," he said, and held out his cup to be filled again.

You can imagine how delighted Raiko was, for he knew full well that the demon was given into his hand. But he dissembled cleverly and said as he filled the ogre's wine-cup: "I am delighted that the Honourable Host should deign to like our poor country wine. While you drink, I and my companions will venture to amuse you by our dancing."

Then Raiko made a sign to his men and they began to chant an accompaniment, while he himself danced.

Shutendoji was highly amused as well as his attendants. They had never seen men dance before, and they thought that the strangers were very entertaining.

The goblins now began to pass the magic wine round and to grow merry. Others meanwhile whispered among themselves, pitying the six travellers who, all unconscious of the horrible fate which was about to overtake them, were spending their last hours of liberty and probably of life in giving wine to their slayers and in dancing and singing for their amusement.

Already, however, the power of the enchanted wine had begun to work and Shutendoji grew drowsy. The wine in the jar never seemed to grow less, however much was taken from it, and by this time all the demons had helped themselves liberally. At last they all fell into a deep sleep, and stretching themselves out on the floor and on one another, some in one corner and some in another, they were soon snoring so loudly that the room shook, and were as insensible to all that was going on as logs of wood.

"The time has come!" said Raiko, springing to his feet, and motioning to his men to get to work. One and all hastily opened their knapsacks. Taking out their helmets, their armour, and their long swords, they armed themselves. When they were all ready they all knelt down, and, placing their hands palm to palm, they prayed fervently to their patron gods to help them now in their hour of greatest need and peril.

As they prayed, a shining light filled the room, and in a radiant cloud the three deities appeared again. "Fear not, Warrior Raiko," they said. "We have tied the hands and feet of the demon fast, so you have nothing to fear. While your knights cut off his limbs, do you cut off his head; then kill the rest of the demons and your work will be done."

The three old men then disappeared as mysteriously as they had come.

Raiko rejoiced at the vision and worshipped with his heart full of gratitude the vanishing deities. The knights then rose from their knees, took their swords and wet the rivets with water, so as to fix the blade firmly in the hilt. Then they all stole stealthily and cautiously towards Shutendoji. No longer the timid mountain priests; clad in full armour, they were transformed into avenging warriors. With flashing eyes and dauntless mien they moved across the room.

The captive princesses standing round realized that these men ere deliverers, from their beloved capital. Their joy and wonder cannot be put into words. Some cried aloud with joy; others covered their faces with their sleeves and burst into soft weeping; others raised their hands to Heaven and exclaimed, "A Buddha come to Hell! Surely these brave men will kill the demons and set us free!"; and with clasped hands they entreated the knights to slay their captors and take them back to their homes.

Now Raiko stood over the sleeping Shutendoji with drawn sword, and raising it on high with a mighty sweep he aimed at the demon's neck, which was as big round as a barrel.

The head was severed from the body at one blow, but, horrible to relate, instead of falling to the ground, it flew up into the air in a great rage. It hung over Raiko for a moment snorting flames of fire, and then swooped down as if it would bite off the warrior's head, but it was daunted by the glittering star on his helmet, and drew back and gazed in surprise at the transformed man. Raiko was scorched by the demon's flaming breath. Once more he raised his long sword and striking the terrible head brought it to the ground at last.

The noise of the combat and the triumphant shouts of the warriors awoke the other demons, who roused themselves as quickly as their stupefied senses allowed them. They were in a great fright, and without waiting to get their iron clubs, they made a rush upon Raiko. But they were too late. His five braves dashed in and attacked them right and left, until in a few minutes there was not one left to tell the tale of the destruction which had come down upon them like the autumn whirlwind upon the leaves of the forest glades.

The captive princesses, when they saw that their captors were all slain, jumped about with gladness, waving their long sleeves to and fro, as the tears of joy streamed down their pale faces. They ran to Raiko and caught hold of his sleeves and praised him, saying: "Oh! Raiko Sama, what a brave and noble knight you are! We are indeed grateful to you for having saved our lives. Never have we seen such a wonderful warrior." And with many such expressions of joy they gathered round the knight, and their merry voices were now heard, instead of the groans of the dying cannibals.

Now that Shutendoji was vanquished with all his horde, the way was quite open for Raiko and his men to take the fair captives away from the castle of horror and make their way back to the capital as soon as possible.

First of all Raiko tied up the head of Shutendoji with a strong rope and told the five brave knights to carry it. Then, followed by the princesses, the little band left Mount Oye forever and set out on the homeward journey. When they reached Kyoto the news of Raiko's return spread like fire, and the people came out in crowds to welcome the heroes.

When the parents of the long-lost damsels saw their daughters again, they felt as if they must be dreaming. It seemed too good to be true that the dear and cherished ones should be restored to them safe and well, and they overwhelmed Raiko with praise and with precious gifts.

Raiko took the head of Shutendoji to the Emperor and told him of all that had happened to him. You may be sure that when His Majesty heard of the success which had crowned Raiko and his expedition, he awarded him great praise and merit and bestowed upon him higher Court rank than ever.

In all the country, far and near, Raiko's name was in every one's mouth, and he was acknowledged to be the greatest warrior in the land. Even in the lonely country places there was not one poor farmer who did not know of the brave deeds of the great general.

ILLUSTRATIONS
Page 106: Raiko and the head of Shutendoji; art by Okubo Tadanobu (c.1765).
Page 107: Raiko, his men and the head of Shutendoji; art by Yoshitora (1850).
Page 110: Raiko and his men on Mount Oye; art by Yoshiiku (1858).
Page 112: Shutendoji's demon orgy; art by Kuniyoshi (1853).
Page 113: Raiko, his men and the head of Shutendoji; art by Katsukawa Shuntei (c.1820).

THE OUTLAWS KIDOMARU AND HAKAMADARE

It was not long after Raiko's ogre-killing exploits at Oyeyama that the country rang with the name of Kidomaru, a robber and highwayman, who, by his notorious deeds of cruelty and robbery, had caused his name to be feared and hated by all, both young and old.

One evening Raiko with his attendants was returning home from a day's hunting, when he happened to pass the house of his younger brother Yorinobu. The warrior had had a long day out; and having still a good distance to ride before he would reach his own house the thought of a good meal and friendly company, just then, when he was tired and very hungry, was pleasant to contemplate in the lonely hour of twilight. So he called a halt outside the house and sent in word to his brother that he, Raiko, was passing by, and that if Yorinobu had any refreshment to offer his brother, he would call in and stay the night there, as he was tired out on his way back from a day's hunt.

Now in Japan an elder brother or sister commands respect from the younger members of the family, and so Yorinobu was very pleased that Raiko, his elder brother, had condescended to call upon him.

The servant soon returned with the message that Yorinobu was only too pleased to receive Raiko; that he had ordered a feast to be prepared that evening in honour of an unusual event, and as he was alone, nothing could be more opportune or give him greater joy than that his elder brother should have chanced to come by. He humbly begged Raiko that he would deign to share the feast, such as it was, and to pardon the poorness of his hospitality.

Raiko was very pleased with his brother's gracious reception. He quickly flung the reins to his groom, dismounted from his horse, and entered the house, wondering what could be the occasion of Yorinobu's ordering a banquet for himself. When the warrior was shown into the room he found Yorinobu seated on the mats drinking saki, as the servants were bringing in the first dishes of the dinner. When the salutations were over, Yorinobu handed Raiko his wine-cup. Raiko took it, and having drained it, asked what his brother meant by the feast he had promised him and what was the occasion of it. Yorinobu laughed as if with triumph, and wheeling round on his cushion pointed out into the garden.

Raiko then looked in the direction indicated by his brother's hand, and saw, tied up to a large pine tree, a young man who could not be much over thirty and of extraordinary strength. The face of the captive expressed hate and ferocity, his body was of an enormous build, while his arms and legs were like trunks of pine trees, so large and brown and muscular were they. His hair was a rough and matted shock, and the eyes glared as if they would start from their sockets. Indeed to Raiko the wild creature looked more like a demon than a human being.

"Well, Yorinobu!" said Raiko, "the occasion of your feast is to say the least unusual; it must certainly have given you some sport to catch that wild creature; but tell me who he is that you have got tied up out there."

"Have you not heard of Kidomaru, the notorious robber?" answered Yorinobu. "There he is! One of my men captured him out on the hills; he found him asleep. The town has long been clamouring for him. He has a big score to settle at last. For to-night I intend to keep him tied up like that, and to-morrow I shall hand him over to the law! Come, let us be merry, for the dinner is served!"

Raiko clapped his hands when he heard of the great feat Yorinobu and his men had accomplished in catching the fearful robber, the terror of whose lawless deeds had long held the people of Kyoto trembling with fear and dread. The outlaw Kidomaru was caught at last and by his own brother Yorinobu! This was an event of rejoicing and congratulation for the family.

"You have certainly done a meritorious service to your country," said he, "but it is ridiculous to tie such a creature up with a rope only. You might just as well think of tying up a wild cow with a fine kite-string. It would be less dangerous. Take my advice, Yorinobu, put a strong iron chain round him, or the murderer will soon be at large again."

Yorinobu thought his brother's advice wise, so he clapped his hands. When the servant came to answer the summons, he ordered him to bring an iron chain. When this was brought, he went into the garden, followed by Raiko and his men, and wound it round Kidomaru's body several times, securing it at last to a post with a padlock.

Kidomaru up to this time had rejoiced at his light bonds. He was so strong that he knew he could easily break a rope, and he had waited but for the nightfall to make good his escape under cover of the darkness. You can imagine how great was his anger at Raiko's interference, which was the cause of his being treated with so much severity that his projected escape would now be difficult.

"Hateful man!" muttered Kidomaru to himself. "I will surely punish you for what you have done to me! Remember!" and he threw evil glances at Raiko.

But the brave warrior cared little for the wild robber's malignant glances; he only laughed when he noticed them, and, as the chain was drawn tighter round the robber, he said: "That's right! That chain will hold him sure enough! You must run no risk of his escaping this time!"

Then he and Yorinobu returned to the house, and dinner was served and the two brothers made merry the whole evening, talking over old times, and it was late before they retired to rest.

Now Kidomaru knew that Raiko slept in Yorinobu's house, and he made up his mind to try to slay him that night, for he was mad with wrath at what Raiko had done to him.

"He shall see what I can do!" growled Kidornaru to himself, shaking his rough and shaggy head like a big long-haired terrier. He waited quietly till every one in the house had gone to rest and all was silent. Then Kidomaru arose, cramped and stiff from sitting tied up so long. With a mighty effort he flung out his great arms, laughing defiance at the chain that bound him. So great was his strength that no second effort was needed; the chain broke and fell clanking to the ground at once, and Kidomaru, like a large hound, shook himself free from his bonds. Softly as a mouse he approached the house and climbed on to the roof, and with one tremendous blow from his huge fist, he broke through the tiles and the boards to the ceiling. His plan was to jump down upon Raiko while he lay sleeping, and taking him unawares suddenly to cut off his head. But the warrior had lain down to rest expecting such an attack, and he had slept but lightly. As soon as he heard the noise above him, he was wide awake in an instant, and to warn his enemy he coughed and cleared his throat. Kidomaru was a man of fierce and dauntless character, and he was not in the least thrown back in his purpose by finding that Raiko was awake. He went on with his work of making a hole large enough in the ceiling to let himself through to the room beneath.

Raiko now sat up and clapped his hands loudly to summon his men, who slept in an adjoining room. Watanabe, the chief man-at-arms, came out to see what his master wanted.

Watanabe," said Raiko, "my sleep has been disturbed by something moving in the ceiling. It may be a weasel, for weasels are noisy creatures. It cannot be a rat, for a rat is not large enough to make so much noise. At any rate, it seems impossible to sleep to-night, so saddle the horses and get all the men ready to start. I will get up and ride out to the Temple of Mount Kurama. I want all the men to accompany me."

Perched between the roof and the ceiling, the robber heard all this, and said to himself: "What ho! Raiko goes to Kurama! That is good news! Instead of wasting my time here like a rat in a trap, I will set out for Kurama immediately and get there before those stupid men can, and I will waylay them and kill them all." So Kidomaru crawled out on the roof again, let himself down to the around, and hurried with all the speed he could make to Kurama.

A large plain had to be crossed in going from the city to Kurama, and here a number of wild cattle had their home. When Kidomaru, on his way to Kurama, came to this spot, a plan flashed across his mind by which he could steal a march on Raiko. He soon caught one of the big oxen a blow on the head. Three blows one after the other, and the ox fell dead at the robber's feet. Kidomaru then proceeded to strip off its skin. It was very hard work, but he managed to do it quickly, so strong was he, and then throwing the hide over himself he lay down completely disguised, a man in a bull's hide, and waited for Raiko and his men to come.

He had not long to wait. Raiko, followed by his four braves, soon came in sight. The warrior reined in his horse when he came to the plain and saw the cattle. He turned to his men and said: "Here is a place where we may find some sport. Instead of going on to Kurama, let us stay here and have some hunting! Look at the wild cattle!"

The four retainers with one accord all gladly agreed to their chief's proposal, for they loved sport and adventure just as much as Raiko and were glad of an excuse to show their skill as huntsmen. The sun was just rising, and the prospect of a fine morning added zest to the pastime. Each man prepared his bow and arrows in readiness to begin the chase.

But the cattle, thus disturbed, did not enjoy the sport. Man's play was their death indeed. One of their number had been killed by Kidomaru, and now they were attacked by Raiko and his men, who came riding furiously into their midst, shooting at them with bows and arrows. With angry snorts, whisking their tails on high and butting with their horns, they ran to right and left. In the general stampede that followed their attack, the hunters noticed that one animal lay still in the tall grass. At first they thought it must be either lame or ill, so they took no notice of it, and left it alone till Raiko came riding up. He went up and looked at it carefully, and then ordered one of his men to shoot it.

The man obeyed, and taking his bow, shot an arrow at the recumbent animal. The arrow did not hit the mark; for, to the astonishment of the four hunters, the hide was flung aside and out stepped the robber Kidomaru.

"You, Raiko! It is you, is it?" exclaimed he. "Do you know that I have a spite against you?" and with these words he darted forward and attacked Raiko with a dagger. But Raiko did not even move in his saddle. He drew his sword and, adroitly guarding himself, exchanged two or three strokes with the robber, and then slashed off his head. But wonderful to relate, so strong was the will that animated Kidomaru that though his head was cut off, his body stood up straight and firm till his right arm, still holding the dagger, struck at Raiko's saddle. Then, and not till then, it collapsed. It is said that the warriors were all greatly impressed by the malevolent spirit of the robber, which was strong enough to stir the body to action even after the head had been severed from the shoulders.

Such was the death of the notorious robber Kidomaru, at the hands of the brave warrior Raiko who was awarded much praise for the clever way in which he drew Kidomaru out as far as Kurama to kill him. He had understood from Kidomaru's evil glances that the robber planned to kill him, and he thus avoided causing trouble in his brother's house. In this instance, as always, Raiko displayed wisdom and bravery.

No sooner, however, was Kidomaru killed, than news was brought to the capital that another man had arisen who imitated Kidomaru in his daily deeds of robbery, snake sorcery and other wicked acts. This robber's name was Hakamadare.

One bright moonlight night, Hakamadare was waiting on the plain between Kyoto and Kurama for travellers to come that way, hoping that luck would bring some rich man into his clutches. Presently he heard some one coming towards him playing on a flute. Thinking this somewhat strange, he hid himself in the grass and waited to see who would appear. The sweet music drew nearer and nearer, and then the player came in view. The light of the moon made everything as clear as day, and the robber saw a handsome samurai of soldierly aspect, dressed in beautiful silken robes and wearing a long sword at his side.

"Now's my opportunity; I'm in luck to-night," thought the robber, as he rose from his hiding-place and stealthily followed the flute-player. As he kept step by step behind him, Hakamadare drew his sword in readiness several times to cut down his prey, and waited for the chance to strike.

All at once the samurai turned and looked steadily at the robber, who began to tremble. Then the knight calmly and coolly resumed his playing, as if utterly indifferent to the danger which threatened him. Once more the robber followed, with the intention of cutting the man down, but the opportunity for which he waited never came; each time his hand went up with his sword, it as quickly fell to his side. A spirit of high and noble purpose seemed to emanate from the knight, which cowed the man behind and made him weak. For so great is the virtue of the sword that in Japan it is an acknowledged fact that all noble swordsmen had this power of subduing lesser natures by the spiritual grace which went forth from them. Indeed the belief in the occult power of the sword was great, and it was said that no bad man could keep the possession of a fine blade.

Hakamadare could not strike. He could not tell the cause of his weakness. He thought that it might be the influence of the music. He found himself listening to the gentle strains of the flute, and admiring the skill with which the man played. He noticed the firm and fearless air of the knight as he walked and his great nerve. The man knew himself to be followed by a robber, yet he showed not the least concern. Hakamadare tried to turn back now, but he found that he could do nothing but follow the man in front of him.

In this way the strange pair reached the town. Hakamadare now made a great effort to break the spell, and was on the point of turning back and trying to escape from the strange, compelling presence, when to his astonishment the samurai suddenly wheeled round upon him and said: "Hakamadare, I thank you for your trouble! You have given

me a safe escort!"

At this the robber became so terrified that he fell down on his knees and was unable to move or speak for some moments. At last, so soon as his tongue found utterance, he said: "I know not who you are, but I beg you to forgive me! I would have killed you!"

He then confessed everything to the knight. He told him of his many deeds of robbery and violence which had made him feared and hated by the people, who thought that he must be a demon, for so cruel and relentless was he that he never showed mercy even to the poorest peasant. "I have never met any one like you," Hakamadare went on to say. "I promise to give up my life as a robber, and I beg you to take me into your service as one of the humblest of your retainers."

The knight led the man home, and gave him some good clothes, telling him that when he again got into straits and wanted money or clothes, he might come a second time to the house, but that it was unwise to show such contempt for others as to enter into an encounter where he himself might be the injured party.

This kindness and mercy touched the man's heart, and from that day he became a reformed man and a law-abiding citizen. The knight was none other than Hirai, one of the warriors who accompanied Raiko in his successful expedition against the demons of Oyeyama.

ILLUSTRATIONS
Page 115: Raiko's retainers ambushed by Kidomaru; art by Toyokuni (c.1815).
Page 118: Raiko's retainers ambushed by Kidomaru; art by Kuniyoshi (1836).
Page 120: Raiko fighting the snake magic of Hakamadare; art by Yoshikazu (1859).

THE EARTH SPIDER

There are two other stories about the General Raiko which you may like to hear. The sword with which Raiko slew Kidomaru was called the Kumokiri, or Spider-cutting Sword, and about the naming of this blade there is an interesting story.

It happened at one time that Raiko was unwell and was obliged to keep his room. Every night at about twelve a little acolyte would come to his bedside, and in a kind and gentle way pour out and give him some medicine to take. Raiko noticed that he did not know the boy, but as there were many underlings in the servants' quarters whom he never saw, this did not strike him as strange. But Raiko, instead of recovering, found himself growing weaker and weaker, and especially after taking the medicine he always felt worse.

At last one day he spoke to his head servant and asked him who it was that brought him medicine every night, but the attendant answered that he knew nothing about the medicine and that there was no acolyte in the house.

Raiko now suspected some supernatural snare. "Some malevolent being is taking advantage of my illness and trying to bewitch me or to cause my death. When the boy comes again tonight I will find out his real form. He may be a fox or goblin in disguise!" said Raiko.

So he waited for the appearance of the acolyte, wondering what the strange incident could mean.

When midnight came, the boy, as usual, appeared, bringing with him the usual cup of medicine. The knight calmly took the cup from the boy and said, "Thank you for your trouble!" but instead of swallowing the false medicine, he threw it, cup and all, at the boy's head. Then jumping up he seized the sword that lay beside his bed and cut at the impostor. As the blade fell, the acolyte screamed with rage and pain, then, with a movement as quick as lightning, before he turned to escape from the room, he threw something at the knight, which, marvellous to relate, as he threw, spread outwards pyramidically into a large white sticky web which fell over Raiko and clung to him so that he could hardly move. Raiko whirled his sword round and cut the clinging meshes and freed himself; again the goblin threw a web over him, and again Raiko cut the enmeshing threads away; once more the huge spider's web – for such it was – was thrown over him, and then the goblin fled. Raiko called for his men and then sank exhausted on his bed.

His chief retainer, answering the summons, met the acolyte in the corridor, and thinking it strange that an unknown priest, however young, should come from his master's room at that hour of the night, stopped him with drawn sword.

The goblin answered not a word, but threw his entangling web over the man and mysteriously disappeared.

Now thoroughly alarmed, the retainer hastened to Raiko. Great was his consternation when he saw his master, with the meshes of the goblin's web still clinging to him.

"See!" exclaimed Raiko, pointing to the threads still clinging to his man and himself, "an earth spider has been here!"

He then gave orders to hunt down the monster, but the thing could nowhere be found. On the white mats and along the corridors they found as they searched red drops of blood, which showed that the creature had been wounded. Raiko's men followed the red trail, out into the garden, across the city to the hills, till they came to a cave, and here the blood-drops ceased. Groans and cries of pain issued from the cave, so the warriors felt sure that they had come to the end of their hunt.

"The earth spider is surely hiding in that cave!" they all said. Drawing their swords, they entered the cave and found a monster spider writhing with pain and bleeding from a deep sword-cut on the head. They at once killed the creature and carried it to Raiko.

The knight had often heard stories of these dreadful spiders, but had never seen one before.

"It was this earth spider then that wanted to prey upon me! The net that was thrown over me was a spider's web! Of all my adventures this is the strangest!" said Raiko.

That night Raiko ordered a banquet to be prepared for all his retainers in honour of the event, and he drank to the health of his five brave men. From that time the strange acolyte never appeared, and Raiko recovered his health and strength at once.

Such is the story of the Kumokiri Sword. *Kumo* means "spider," and *kiri* means "cutting," and it was so named because it cut to death the earth spider who haunted the brave knight Raiko.

Raiko's second encounter with the earth spider was even stranger. Whilst hunting down evil spirits, Raiko and his men saw a huge, fiery skull, floating in the air. They quickly chased after it, and it led them away from the city and into the hills. Here they came across a huge, seemingly deserted palace.

They entered and decioded to rest there awhile. But as Sakata Kintoki and Watanabe Tsuna sat playing a game of *go*, they were suddenly assailed by a huge army of hideous *yokai*. These demons were seemingly under the command of a mysterious, exceedingly beautiful woman. When Raiko saw her, he stood dumb-founded, as if under a spell. Soon, he felt himself being ensnared by the strands of a silky cobweb and, ewaking from his trance, struck out at the woman with his sword. As the sword cut into her, the woman transmuted into her true self – a foul, gnashing earth spider. As the *yokai* evaporated, Raiko sliced open the spider's belly; out poured thousands of baby spiders, as big as puppies, which Raiko and his men set to destroying. The dying spider also disgorged the skulls of its countless victims, so that the palace now resembled a slaughterhouse of butchered spiders and human bones.

Once all the spiders were dead, Raiko and his men hurried back to the city, glad that this nightmare was over.

ILLUSTRATIONS
Page 121: Raiko's retainers attacking the earth spider; art by Kunisada (c.1815).
Page 123: Sakata Kintoki and Watanabe Tsuna assailed by *yokai*; art by Sadahide (1843).

THE LEGEND OF KINTARO

Long, long ago there lived in Kyoto a brave soldier named Kintoki. Now he fell in love with a beautiful lady and married her. Not long after this, through the malice of some of his friends, he fell into disgrace at Court and was dismissed. This misfortune so preyed upon his mind that he did not long survive his dismissal – he died, leaving behind him his beautiful young wife to face the world alone. Fearing her husband's enemies, she fled to the Ashigara Mountains as soon as her husband was dead, and there in the lonely forests where no one ever came except

坂田怪童丸

woodcutters, a little boy was born to her. She called him Kintaro or the Golden Boy. Now the remarkable thing about this child was his great strength, and as he grew older he grew stronger and stronger, so that by the time he was eight years of age he was able to cut down trees as quickly as the woodcutters. Then his mother gave him a large axe, and he used to go out in the forest and help the woodcutters, who called him "Wonder-child", and his mother Yamauba, the "Old Nurse of the Mountains", for they did not know her high rank. Another favourite pastime of Kintaro's was to smash up rocks and stones. You can imagine how strong he was!

Quite unlike other boys, Kintaro, grew up all alone in the mountain wilds, and as he had no companions he made friends with all the animals and learned to understand them and to speak their strange talk. By degrees they all grew quite tame and looked upon Kintaro as their master, and he used them as his servants and messengers. But his special retainers were the bear, the deer, the monkey and the hare.

The bear often brought her cubs for Kintaro to romp with, and when she came to take them home Kintaro would get on her back and have a ride to her cave. He was very fond of the deer too, and would often put his arms round the creature's neck to show that its long horns did not frighten him. Great was the fun they all had together.

One day, as usual, Kintaro went up into the mountains, followed by the bear, the deer, the monkey, and the hare. After walking for some time up hill and down dale and over rough roads, they suddenly came out upon a wide and grassy plain covered with pretty wild flowers.

Here, indeed, was a nice place where they could all have a good romp together. The deer rubbed his horns against a tree for pleasure, the monkey scratched his back, the hare smoothed his long ears, and the bear gave a grunt of satisfaction.

Kintaro said, "Here is a place for a good game. What do you all say to a wrestling match?"

The bear being the biggest and the oldest, answered for the others:

"That will be great fun," said she. "I am the strongest animal, so I will make the platform for the wrestlers;" and she set to work with a will to dig up the earth and to pat it into shape.

"All right," said Kintaro, "I will look on while you all wrestle with each other. I shall give a prize to the one who wins in each round."

"What fun! we shall all try to get the prize," said the bear.

The deer, the monkey and the hare set to work to help the bear raise the platform on which they were all to wrestle. When this was finished, Kintaro cried out:

"Now begin! the monkey and the hare shall open the sports and the deer shall be umpire. Now, Mr. Deer, you are to be umpire!"

"He, he!" answered the deer. "I will be umpire. Now, Mr. Monkey and Mr. Hare, if you are both ready, please walk out and take your places on the platform."

Then the monkey and the hare both hopped out, quickly and nimbly, to the wrestling platform. The deer, as umpire, stood between the two and called out:

"Red-back! Red-back!" (this to the monkey, who has a red back in Japan). "Are you ready?"

Then he turned to the hare:

"Long-ears! Long-ears! are you ready?"

Both the little wrestlers faced each other while the deer raised a leaf on high as signal. When he dropped the leaf the monkey and the hare rushed upon each other, crying "Yoisho, yoisho!"

While the monkey and the hare wrestled, the deer called out encouragingly or shouted warnings to each of them as the hare or the monkey pushed each other near the edge of the platform and were in danger of falling over.

"Red-back! Red-back! stand your ground!" called out the deer.

"Long-ears! Long-ears! be strong, be strong – don't let the monkey beat you!" grunted the bear.

So the monkey and the hare, encouraged by their friends, tried their very hardest to beat each other. The hare at last gained on the monkey. The monkey seemed to trip up, and the hare giving him a good push sent him flying off the platform with a bound.

The poor monkey sat up rubbing his back, and his face was very long as he screamed angrily. "Oh, oh! how my back hurts – my back hurts me!"

Seeing the monkey in this plight on the ground, the deer holding his leaf on high said:

"This round is finished – the hare has won."

Kintaro then opened his luncheon box and taking out a rice-dumpling, gave it to the hare saying:

"Here is your prize, and you have earned, it well!"

Now the monkey got up looking very cross, and as they say in Japan "his stomach stood up," for he felt that he had not been fairly beaten. So he said to Kintaro and the others who were standing by:

"I have not been fairly beaten. My foot slipped and I tumbled. Please give me another chance and let the hare wrestle with me for another round."

Then Kintaro consenting, the hare and the monkey began to wrestle again. Now, as every one knows, the monkey is a cunning animal by nature, and he made up his mind to get the best of the hare this time if it were possible. To do this, he thought that the best and surest way would be to get hold of the hare's long ear. This he soon managed to do. The hare was quite thrown off his guard by the pain of having his long ear pulled so hard, and the monkey seizing his opportunity at last, caught hold of one of the hare's legs and sent him sprawling in the middle of the dais. The monkey was now the victor and received, a rice-dumpling from Kintaro, which pleased him so much that he quite forgot his sore back.

The deer now came up and asked the hare if he felt ready for another round, and if so whether he would try a round with him, and the hare consenting, they both stood up to wrestle. The bear came forward as umpire.

The deer with long horns and the hare with long ears, it must have been an amusing sight to those who watched this queer match. Suddenly the deer went down on one of his knees, and the bear with the leaf on high declared him beaten. In this way, sometimes the one, sometimes the other, conquering, the little party amused themselves till they were tired.

At last Kintaro got up and said:

"This is enough for to-day. What a nice place we have found for wrestling; let us come again to-morrow. Now, we will all go home. Come along!" So saying, Kintaro led the way while the animals followed.

After walking some little distance they came out on the banks of a river flowing through a valley. Kintaro and his four furry friends stood and looked about for some means of crossing. Bridge there was none. The river rushed "don, don" on its way. All the animals looked serious, wondering how they could cross the stream and get home that evening.

Kintaro, however, said:

"Wait a moment. I will make a good bridge for you all in a few minutes."

The bear, the deer, the monkey and the hare looked at him to see what he would do now.

Kintaro went from one tree to another that grew along the river bank. At last he stopped in front of a very large tree that was growing at the water's edge. He took hold of the trunk and pulled it with all his might, once, twice, thrice! At the third pull, so great was Kintaro's strength that the roots gave way, and "meri, meri" (crash, crash), over

fell the tree, forming an excellent bridge across the stream.

"There," said Kintaro, "what do you think of my bridge? It is quite safe, so follow me," and he stepped across first. The four animals followed. Never had they seen any one so strong before, and they all exclaimed:

"How strong he is! how strong he is!"

While all this was going on by the river a woodcutter, who happened to be standing on a rock overlooking the stream, had seen all that passed beneath him. He watched with great surprise Kintaro and his animal companions. He rubbed his eyes to be sure that he was not dreaming when he saw this boy pull over a tree by the roots and throw it across the stream to form a bridge.

The woodcutter, for such he seemed to be by his dress, marveled at all he saw, and said to himself:

"This is no ordinary child. Whose son can he be? I will find out before this day is done."

He hastened after the strange party and crossed the bridge behind them. Kintaro knew nothing of all this, and little guessed that he was being followed. On reaching the other side of the river he and the animals separated, they to their lairs in the woods and he to his mother, who was waiting for him.

As soon as he entered the cottage, which stood like a matchbox in the heart of the pine-woods, he went to greet his mother, saying:

"Okkasan (mother), here I am!"

"O, Kimbo!" said his mother with a bright smile, glad to see her boy home safe after the long day. "How late you are to-day. I feared that something had happened to you. Where have you been all the time?"

"I took my four friends, the bear, the deer, the monkey, and the hare, up into the hills, and there I made them try a wrestling match, to see which was the strongest. We all enjoyed the sport, and are going to the same place to-morrow to have another match."

"Now tell me who is the strongest of all?" asked his mother, pretending not to know.

"Oh, mother," said Kintaro, "don't you know that I am the strongest? There was no need for me to wrestle with any of them."

"But next to you then, who is the strongest?"

"The bear comes next to me in strength," answered Kintaro.

"And after the bear?" asked his mother again.

"Next to the bear it is not easy to say which is the strongest, for the deer, the monkey, and the hare all seem to be as strong as each other," said Kintaro.

Suddenly Kintaro and his mother were startled by a voice from outside.

"Listen to me, little boy! Next time you go, take this old man with you to the wrestling match. He would like to join the sport too!"

It was the old woodcutter who had followed Kintaro from the river. He slipped off his clogs and entered the cottage. Yamauba and her son were both taken by surprise. They looked at the intruder wonderingly and saw that he was some one they had never seen before.

"Who are you?" they both exclaimed.

Then the woodcutter laughed and said:

"It does not matter who I am yet, but let us see who has the strongest arm – this boy or myself?"

Then Kintaro, who had lived all his life in the forest, answered the old man without any ceremony, saying:

"We will have a try if you wish it, but you must not be angry whoever is beaten."

Then Kintaro and the woodcutter both put out their right arms and grasped each other's hands. For a long

time Kintaro and the old man wrestled together in this way, each trying to bend the other's arm, but the old man was very strong, and the strange pair were evenly matched. At last the old man desisted, declaring it a drawn game.

"You are, indeed, a very strong child. There are few men who can boast of the strength of my right arm!" said the woodcutter. "I saw you first on the hanks of the river a few hours ago, when you pulled up that large tree to make a bridge across the torrent. Hardly able to believe what I saw I followed you home. Your strength of arm, which I have just tried, proves what I saw this afternoon. When you are full-grown you will surely be the strongest man in all Japan. It is a pity that you are hidden away in these wild mountains."

Then he turned to Kintaro's mother:

"And you, mother, have you no thought of taking your child to the Capital, and of teaching him to carry a sword as befits a samurai (a Japanese knight)?"

"You are very kind to take so much interest in my son." replied the mother; "but he is as you see, wild and uneducated, and I fear it would be very difficult to do as you say. Because of his great strength as an infant I hid him away in this unknown part of the country, for he hurt every one that came near him. I have often wished that I could, one day, see my boy a knight wearing two swords, but as we have no influential friend to introduce us at the Capital, I fear my hope will never come true."

"You need not trouble yourself about that. To tell you the truth I am no woodcutter! I am one of the great generals of Japan. My name is Sadamitsu, and I am a vassal of the powerful Lord Minamoto-no-Raiko. He ordered me to go round the country and look for boys who give promise of remarkable strength, so that they may be trained as soldiers for his army. I thought that I could best do this by assuming the disguise of a woodcutter. By good fortune, I have thus unexpectedly come across your son. Now if you really wish him to be a SAMURAI (a knight), I will take him and present him to the Lord Raiko as a candidate for his service. What do you say to this?"

As the kind general gradually unfolded his plan the mother's heart was filled with a great joy. She saw that here was a wonderful chance of the one wish of her life being fulfilled – that of seeing Kintaro a SAMURAI before she died.

Bowing her head to the ground, she replied:

"I will then intrust my son to you if you really mean what you say."

Kintaro had all this time been sitting by his mother's side listening to what they said. When his mother finished speaking, he exclaimed:

"Oh, joy! joy! I am to go with the general and one day I shall be a SAMURAI!"

Thus Kintaro's fate was settled, and the general decided to start for the Capital at once, taking Kintaro with him. It need hardly be said that Yamauba was sad at parting with her boy, for he was all that was left to her. But she hid her grief with a strong face, as they say in Japan. She knew that it was for her boy's good that he should leave her now, and she must not discourage him just as he was setting out. Kintaro promised never to forget her, and said that as soon as he was a knight wearing two swords he would build her a home and take care of her in her old age.

All the animals, those he had tamed to serve him, the bear, the deer, the monkey, and the hare, as soon as they found out that he was going away, came to ask if they might attend him as usual. When they learned that he was going away for good they followed him to the foot of the mountain to see him off.

"Kimbo," said his mother, "mind and be a good boy."

"Mr. Kintaro," said the faithful animals, "we wish you good health on your travels."

Then they all climbed a tree to see the last of him, and from that height they watched him and his shadow gradually grow smaller and smaller, till he was lost to sight.

The general Sadamitsu went on his way rejoicing at having so unexpectedly found such a prodigy as Kintaro. Having arrived at their destination the general took Kintaro at once to his Lord, Minamoto-no-Raiko, and told him all about Kintaro and how he had found the child. Lord Raiko was delighted with the story, and having commanded Kintaro to be brought to him, made him one of his vassals at once.

Lord Raiko's army was famous for its band called "The Four Braves." These warriors were chosen by himself from amongst the bravest and strongest of his soldiers, and the small and well-picked band was distinguished throughout the whole of Japan for the dauntless courage of its men.

When Kintaro grew up to be a man his master made him the Chief of the Four Braves. He was by far the strongest of them all. Soon after this event, news was brought to the city that a cannibal monster had taken up his abode not far away and that people were stricken with fear. Lord Raiko ordered Kintaro to the rescue. He immediately started off, delighted at the prospect of trying his sword.

Surprising the monster in its den, he made short work of cutting off its great head, which he carried back in triumph to his master.

Kintaro now became known as Sakata Kintoki, and rose to be the greatest hero of his country, and great was the power and honor and wealth that came to him. He now kept his promise and built a comfortable home for his old mother, who lived happily with him in the Capital to the end of her days.

Is not this the story of a great hero?

ILLUSTRATIONS
Page 124: Kintaro and his mother, Yamauba; art by Yoshitoshi (1873).
Page 125: Kintaro shaking tengu out of a tree; art (*surimono*) by Hokkei (c.1830).
Page 126: Kintaro wrestling with two bears; art by Kuniyoshi (c.1840).
Page 129: Kintaro and a wrestling match between the monkey and the hare; art by Kuniyoshi (c.1840).
Page 131: Kintaro wrestling with Sadamitsu; art by Yoshikazu (1860).
Page 132: Kintaro catching a giant carp; art by Kuniyoshi (c.1836).

ONIBABA, CANNIBAL HAG OF ADACHI MOOR

Long, long ago there was a large plain called Adachigahara, in the province of Mutsu in Japan. This place was said to be haunted by a cannibal goblin who took the form of an old woman. From time to time many travelers disappeared and were never heard of more, and the old women round the charcoal braziers in the evenings, and the girls washing the household rice at the wells in the mornings, whispered dreadful stories of how the missing folk had been lured to the goblin's cottage and devoured, for the goblin lived only on human flesh. No one dared to venture near the haunted spot after sunset, and all those who could, avoided it in the daytime, and travelers were warned of the dreaded place. One day as the sun was setting, a priest came to the plain. He was a belated traveler, and his robe showed that he was a Buddhist pilgrim walking from shrine to shrine to pray for some blessing or to crave for forgiveness of sins. He had apparently lost his way, and as it was late he met no one who could show him the road or warn him of the haunted spot.

He had walked the whole day and was now tired and hungry, and the evenings were chilly, for it was late autumn, and he began to be very anxious to find some house where he could obtain a night's lodging. He found himself lost in the midst of the large plain, and looked about in vain for some sign of human habitation.
At last, after wandering about for some hours, he saw a clump of trees in the distance, and through the trees he caught sight of the glimmer of a single ray of light. He exclaimed with joy:

"Oh. surely that is some cottage where I can get a night's lodging!"

Keeping the light before his eyes he dragged his weary, aching feet as quickly as he could towards the spot, and soon came to a miserable-looking little cottage. As he drew near he saw that it was in a tumble-down condition, the bamboo fence was broken and weeds and grass pushed their way through the gaps. The paper screens which serve as windows and doors in Japan were full of holes, and the posts of the house were bent with age and seemed scarcely able to support the old thatched roof. The hut was open, and by the light of an old lantern an old woman sat industriously spinning.

The pilgrim called to her across the bamboo fence and said: "O Baa San [old woman], good evening! I am a traveler! Please excuse me, but I have lost my way and do not know what to do, for I have nowhere to rest to-night. I beg you to be good enough to let me spend the night under your roof."

The old woman as soon as she heard herself spoken to stopped spinning, rose from her seat and approached the intruder.

"I am very sorry for you. You must indeed be distressed to have lost your way in such a lonely spot so late at night. Unfortunately I cannot put you up, for I have no bed to offer you, and no accommodation whatsoever for a guest in this poor place!"

"Oh, that does not matter," said the priest; "all I want is a shelter under some roof for the night, and if you will be good enough just to let me lie on the kitchen floor I shall be grateful. I am too tired to walk further to-night, so I hope you will not refuse me, otherwise I shall have to sleep out on the cold plain." And in this way he pressed the old woman to let him stay.

She seemed very reluctant, but at last she said: "Very well, I will let you stay here. I can offer you a very poor welcome only, but come in now and I will make a fire, for the night is cold."

The pilgrim was only too glad to do as he was told. He took off his sandals and entered the hut. The old woman then brought some sticks of wood and lit the fire, and bade her guest draw near and warm himself.

"You must be hungry after your long tramp," said the old woman. "I will go and cook some supper for you." She then went to the kitchen to cook some rice.

After the priest had finished his supper the old woman sat down by the fire-place, and they talked together for a long time. The pilgrim thought to himself that he had been very lucky to come across such a kind, hospitable old woman. At last the wood gave out, and as the fire died slowly down he began to shiver with cold just as he had done when he arrived.

"I see you are cold," said the old woman; "I will go out and gather some wood, for we have used it all. You must stay and take care of the house while I am gone."

"No, no," said the pilgrim, "let me go instead, for you are old, and I cannot think of letting you go out to get wood for me this cold night!"

The old woman shook her head and said: "You must stay quietly here, for you are my guest." Then she left him and went out.

In a minute she came back and said: "You must sit where you are and not move, and whatever happens don't go near or look into the inner room. Now mind what I tell you!"

"If you tell me not to go near the back room, of course I won't," said the priest, rather bewildered.

The old woman then went out again, and the priest was left alone. The fire had died out, and the only light in the hut was that of a dim lantern. For the first time that night he began to feel that he was in a weird place, and the old woman's words, "Whatever you do don't peep into the back room," aroused his curiosity and his fear.

What hidden thing could be in that room that she did not wish him to see? For some time the remembrance of his promise to the old woman kept him still, but at last he could no longer resist his curiosity to peep into the forbidden place. He got up and began to move slowly towards the back room. Then the thought that the old woman would be very angry with him if he disobeyed her made him come back to his place by the fireside.

As the minutes went slowly by and the old woman did not return, he began to feel more and more frightened, and to wonder what dreadful secret was in the room behind him. He must find out.

"She will not know that I have looked unless I tell her. I will just have a peep before she comes back," said the man to himself.

With these words he got up on his feet and stealthily crept towards the forbidden spot. With trembling hands he pushed back the sliding door and looked in. What he saw froze the blood in his veins. The room was full of dead men's bones and the walls were splashed and the floor was covered with human blood. In one corner skull upon skull rose to the ceiling, in another was a heap of arm bones, in another a heap of leg bones. The sickening smell made him faint. He fell backwards with horror, and for some time lay in a heap with fright on the floor, a pitiful sight. He trembled all over and his teeth chattered, and he could hardly crawl away from the dreadful spot.

"How horrible!" he cried out. "What awful lair have I come to in my travels? May Buddha help me or I am lost. Is it possible that that kind old woman is really the cannibal goblin? When she comes back she will show herself in her true character and eat me up at one mouthful!"

With these words his strength came back to him and, snatching up his hat and staff, he rushed out of the house as fast as his legs could carry him. Out into the night he ran, his one thought to get as far as he could from the goblin's haunt. He had not gone far when he heard steps behind him and a voice crying: "Stop! stop!"

He ran on, redoubling his speed, pretending not to hear. As he ran he heard the steps behind him come nearer and nearer, and at last he recognized the old woman's voice which grew louder and louder as she came nearer.

"Stop! stop, you wicked man, why did you look into the forbidden room?"

The priest quite forgot how tired he was and his feet flew over the ground faster than ever. Fear gave him strength, for he knew that if the goblin caught him he would soon be one of her victims. With all his heart he repeated the prayer to Buddha: "Namu Amida Butsu, Namu Amida Butsu."

And after him rushed the dreadful old hag, her hair flying in the wind, and her face changing with rage into the demon that she was. In her hand she carried a large blood-stained knife, and she still shrieked after him, "Stop! stop!"

At last, when the priest felt he could run no more, the dawn broke, and with the darkness of night the goblin vanished and he was safe. The priest now knew that he had met Onibaba, the cannibal hag of Adachigahara, the story of whom he had often heard but never believed to be true. He felt that he owed his wonderful escape to the protection of Buddha to whom he had prayed for help, so he took out his rosary and bowing his head as the sun rose he said his prayers and made his thanksgiving earnestly. He then set forward for another part of the country, only too glad to leave the haunted plain behind him.

ILLUSTRATIONS
Page 134: The cannibal hag (detail from triptych); art by Kuniyoshi, from the series **Fashionable Living Dolls** (1856).
Page 135: **The Lonely House On Adachi Moor**; art by Kuniyoshi (1856).

THE AUSTERITIES OF MONGAKU

Mongaku was formerly known as Endo Musha Morito and was the son of Watanabe-no-Endo Sakon-no-Shogen Mochito, having been a retainer of Josei-mon-in, a consort of Toba-in, but at the age of nineteen, possessed by a desire to enter the Way of Buddha, he shaved his head and started to practise mortification of the flesh. With the intention of proving how much he could endure, he stripped himself naked and lay dawn on his back in a bamboo thicket in the depth of the mountains under the scorching sun during the hottest days of the sixth month, when there was no breath of wind, and the horse flies and mosquitoes and wild bees and ants and every kind of poisonous insect came and settled on his body and bit and stung him; but in spite of this he did not move a muscle. Thus he remained for the space of seven days, but on the eighth day he arose and asked whether religious asceticism demanded as much as this or not. "If it was so severe," was the reply, "how could people, survive it?"

Thus reassured, he began his austere life by going to Kumano, intending to live in retirement at Nachi. Now at Nachi is a famous waterfall, and Mongaku determined to bathe in it as a religious exercise. It was past the tenth day of the twelfth month when he arrived there and the snow had fallen thickly; the river that ran through the valley was silent in its icy shroud; the freezing blasts blew fiercely from the mountain-tops and the water-fall was a mass of crystal icicles, while the twigs were everywhere hidden under their heavy coat of snow. Mongaku, invoking the magic power of Fudo Myo-o, immersed himself up to the neck in the pool of the waterfall and remained thus two, three, then four days, but on the fifth, unable to endure any longer, losing his senses he was washed away by the mighty volume of the falling water, and carried some six or seven hundred yards down stream, his body dashing against the sharp-edged rocks as it rose and fell in the swirling current. Then suddenly there appeared a beautiful boy who seized his hand and drew him safely up on to the bank. The bystanders, seeing his dangerous plight, soon kindled a fire and warmed him so that he recovered consciousness, for it was not his fate to perish, but as soon as he again drew his breath and opened his eyes, he glared about him in great anger, crying out with a loud voice: "I am under a vow to stand under the waterfall for thrice seven days and repeat the magic invocation of Fudo three hundred thousand times, and today being only the fifth day, who has dared to pull me out?" On hearing these words the hair of their heads stood up and they could say nothing.

Then Mongaku plunged again into the waterfall and stood as before for two days, and on the second day eight boys appeared and grasped both his hands to draw him from the water, but he resisted them strongly and would not move. On the third day he again became as one dead, whereupon, that the waterfall should not be polluted, two heavenly youths, with their hair bound up tightly, descended from above the fall, and rubbed the whole body of Mongaku from head to foot with their warm and perfumed hands, so that he breathed again as one in a dream, and asked who it might be that thus had compassion on him. "We are Kongara and Seitaka, the messengers of Fudo Myo-o," replied the two youths, "and we have come in obedience to the command of the Myo-o, who told us: 'Mongaku has made a sublime vow and is now undergoing unparalleled austerities; go ye and succour him'." Mongaku clasped his hands and exclaimed fervently: "Now am I full of hope, for even Fudo Myo-o knows of my austerities," and he again took up his position in the waterfall.

ILLUSTRATION
Page 138: Mongaku sees a vision of Fudo Myo-o (both portrayed by *kabuki* ctor Ichikawa Danjuro) beneath the waterfall; art (*yakusha-e* triptych panel) by Kunichika (1883).

THE DRAGON KING

Soon after her arrival at home, the empress Jingu gave birth to a son, whom she named Ojin. He was one of the fairest children ever born of an imperial mother, and was very wise and wonderful even when an infant. He was a great favourite of Takénouchi, the prime minister of the empress. This Takénouchi was a very venerable old man, who was said to be three hundred and sixty years old. He had been the counsellor of five mikados.

Now the empress, as well as Takénouchi, wished the imperial infant Ojin to live long, be wise and powerful, become a mighty warrior, be invulnerable in battle, and to have control over the tides and the ocean as his mother once had. To do this it was necessary to obtain the Tide Jewels.

So Takénouchi took the infant Ojin on his shoulders, mounted the imperial war-barge, whose sails were of gold-embroidered silk, and bade his rowers put out to sea. Then standing upright on the deck, he called on Kai Riu O to come up out of the deep and give back the Tide Jewels to Ojin.

At first there was no sign on the waves that Kai Riu O heard. The green sea lay glassy in the sunlight, and the waves laughed and curled above the sides of the boat. Still Takénouchi listened intently and waited reverently. He was not long in suspense. Looking down far under the sparkling waves, he saw the head and fiery eyes of a dragon mounting upward. Instinctively he clutched his robe with his right hand, and held Ojin tightly on his shoulder, for this time not Isora, but the terrible Kai Riu O himself was coming.

What a great honour! The sea-king's servant, Isora, had appeared to a woman, the empress Jingu, but to her son, the Dragon King of the World Under the Sea deigned to come in person.

The waters opened; the waves rolled up, curled, rolled into wreaths and hooks and drops of foam, which flecked the dark green curves with silvery bells. First appeared a living dragon with fire-darting eyes, long flickering moustaches, glittering scales of green all ruffled, with terrible spines erect, and the joints of the fore-paws curling out jets of red fire. This living creature was the helmet of the Sea King. Next appeared the face of awful majesty and stern mien, as if with reluctant condescension, and then the jewel robes of the monarch. Next rose into view a huge haliotis shell, in which, on a bed of rare gems from the deep sea floor, glistened, blazed and flashed the two Jewels of the Tides.

Then the Dragon-King spoke, saying:

"Quick, take this casket, I deign not to remain long in this upper world of mortals. With these I endow the imperial prince of the Heavenly line of the mikados of the Divine country. He shall be invulnerable in battle. He shall have long life. To him I give power over sea and land. Of this, let these Tide-Jewels be the token."

Hardly were these words uttered when the Dragon-King disappeared with a tremendous splash. Takénouchi standing erect but breathless amid the crowd of rowers who, crouching at the boat's bottom had not dared so much as to lift up their noses, waited a moment, and then gave the command to turn the prow to the shore.

Ojin grew up and became a great warrior, invincible in battle and powerful in peace. He lived to be one hundred and eleven years old, and was next to the last of the long lived mikados of Everlasting Great Japan.

ILLUSTRATION
Page 140: The Dragon King presents the Tide Jewels; art (*surimono*) by Hokkei (c.1820).

BENKEI AND THE BELL OF MIIDERA

On one of the hills overlooking the blue sky's mirror of Lake Biwa, stands the ancient monastery of Miidera which was founded over 1,200 years ago, by the pious mikado Tenchi. Near the entrance, on a platform constructed of stoutest timbers, stands a bronze bell five and a half feet high. This old bell, which is visited by thousands of people from all parts of Japan who come to wonder at it, is remarkable for many things.

Over two thousand years ago, say the bonzes, it hung in the temple of Gihon Shoja in India which Buddha built. After his death it got into the possession of the Dragon King of the World under the Sea. When the hero Toda the Archer shot the enemy of the queen of the Under-world, she presented him with many treasures and among them this great bell, which she caused to be landed on the shores of the lake. Toda however was not able to remove it, so he presented it to the monks at Miidera. With great labour it was brought to the hill-top and hung in this belfry where it rung out daily matins and orisons, filling the lake and hill sides with sweet melody.

Now it was one of the rules of the Buddhists that no woman should be allowed to ascend the hill or enter the monastery of Miidera. The bonzes associated females and wicked influences together. Hence the prohibition. When a certain beautiful concubine who lived in Kyoto heard this, she grew extremely inquisitive, and at last, unable to restrain her curiosity, she said: "I will go and see this wonderful bell of Miidera. I will make it send forth a soft note, and in its shining surface, bigger and brighter than a thousand mirrors, I will paint and powder my face and dress my hair."

At length this vain and irreverent woman reached the belfry in which the great bell was suspended, at a time when all were absorbed in their sacred duties. She looked into the gleaming bell and saw her pretty eyes, flushed cheeks, and laughing dimples. Presently she stretched forth her little fingers, lightly touched the shining metal, and prayed that she might have as great and splendid a mirror for her own. When the bell felt this woman's fingers, the bronze that she touched shrank, leaving a little hollow, and losing at the same time all its exquisite polish.

When Benkei was a monk, he was possessed of a mighty desire to steal this bell and hang it up at Hiyeisan. So one night he went over to Miidera hill and cautiously crept up to the belfry and unhooked it from the great iron link which held it. How to get it down the mountain was now the question.

So climbing into the belfry he pulled out the cross-beam with the iron link, and hanging on the bell put the beam on his shoulder to carry it in *tembimbo* style, that is, like a pair of scales. The work made him puff and blow and sweat until he was as hungry as a badger, but he finally succeeded in hooking it up in the belfry at Hiyeisan.

But whenever Benkei rang the bell, it made a hideous and sorrowful sound, as if begging to go back to Miidera. Even a sprinkling of holy water had no effect, the bell only moaned over and over again, pining for its home.

At last Benkei in a rage unhooked the bell, shouldered it beam and all, and set off to take it back. Carrying the bell to the top of Hiyeisan, he set it down, and giving it a kick rolled it down the valley toward Miidera, and left it there. Then the Miidera bonzes hung it up again. Since that time the bell has completely changed its note, until now it is just like other bells in sound and behaviour.

ILLUSTRATION

Page 142: Benkei lifting the great bell of Miidera (triptych panel); art by Kuniyoshi (c.1845).

End Page: A child's nightmare of *yokai*; art by Utamaro (c.1800).